THE BEDFORD HOURS

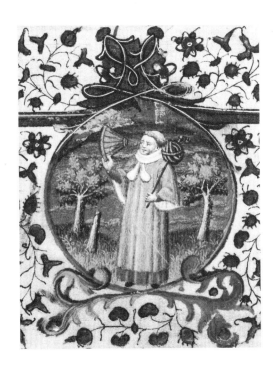

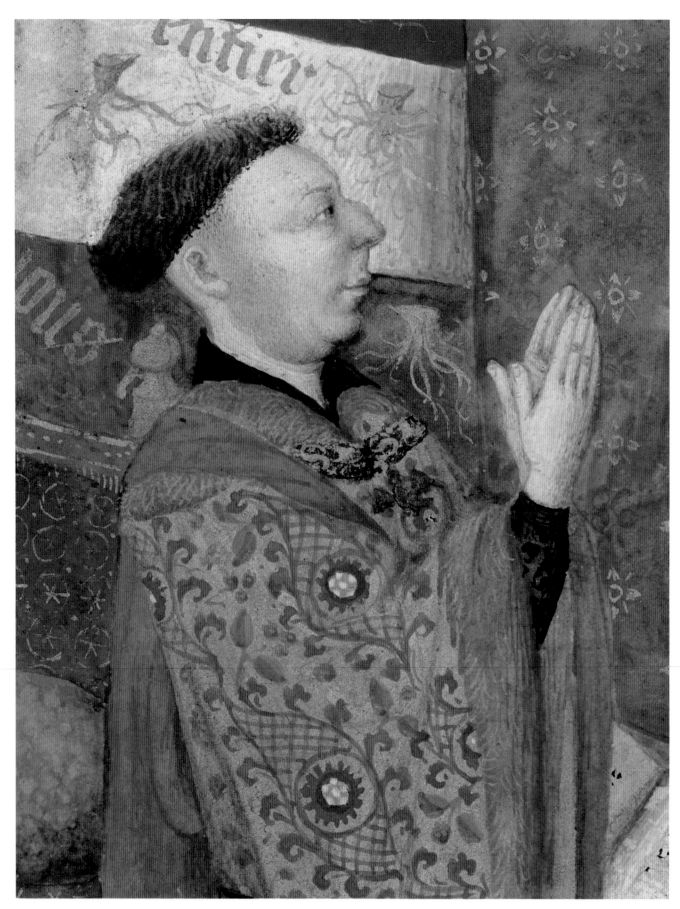

Portrait of John of Lancaster, Duke of Bedford (f. 256b *detail*).

THE BEDFORD HOURS

Janet Backhouse

THE BRITISH LIBRARY

Front cover: Queen Clothilda, attended by her ladies, receives the fleurs de lys (f. 288b detail)

Back cover: Marginal roundel from the calendar; the trumpeters of the Emperor Augustus proclaiming universal peace in his time (f. 8b detail)

Half-title: An astronomer, from the calendar for January (f. 1b detail)

This page: A violent storm, from the calendar for March (f. 3b detail)

© 1990 The British Library Board

First published 1990 by
The British Library, Great Russell Street,
London WC1B 3DG

British Library Cataloguing in Publication Data
Backhouse, Janet
 The Bedford Hours.
 1. Illuminated manuscripts
 I. Title II. British Library
 091

ISBN 0 7123 0231 X

Photography by Laurence Pordes

Designed by James Shurmer

Typeset in Linotron 300 Bembo
by Bexhill Phototypesetters, Bexhill-on-Sea

Origination by York House Graphics, Hanwell

Printed in England by The Roundwood Press
(Southam)

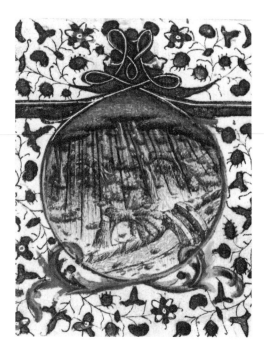

THE BEDFORD HOURS

On 13 May 1423, in the church of St John at Troyes in Champagne, John of Lancaster, Duke of Bedford, married Anne of Burgundy. It was a political match. The bridegroom, a few weeks short of his thirty-fourth birthday, was the elder of the two surviving brothers of King Henry V of England, victor of Agincourt, who had died on 30 August 1422 leaving Bedford Regent of France in the name of his son, the infant Henry VI. The eighteen-year-old bride was one of the younger sisters of Philip, Duke of Burgundy, England's principal ally since the assassination of his father, Duke John the Fearless, at Montereau on 10 September 1419. The church in which the ceremony took place was the parish church of that part of Troyes in which the English royal lodgings stood. As such it had already accommodated the wedding of Henry V himself to Princess Catherine of France less than three years earlier, cementing the Treaty of Troyes by which the succession to the crown of France had been ceded to Henry and his heirs. The Bedford wedding also cemented a treaty, the Treaty of Amiens concluded in the previous month between the Dukes of Bedford, Burgundy and Brittany to guarantee continued support for English rule in France.

The Bedford marriage is commemorated by one of the most splendid illuminated books of the age, the magnificent Bedford Book of Hours, which is now Additional MS 18850 in The British Library. Its contents leave no doubt of its original ownership, for it includes miniatures of both partners, each accompanied by a patron saint, and no less than seven displays of their arms, mottoes and devices.

THE ANGLO-BURGUNDIAN ALLIANCE

Arranged marriages between ruling houses played an important part in the diplomacy of the Middle Ages. They frequently took place while the contracting parties, children of the principals, were still in infancy, and it was not at all unusual for such marriages to be repudiated in the interest of a more advantageous alliance before the children themselves had come of age. Philip of Burgundy's father and grandfather had made full use of this device in framing their policies. Almost two decades earlier, in 1404, Philip's eldest sister Margaret, aged about ten, had been married to Louis of Guyenne, heir to the French throne, having previously been promised to his elder brother Charles, who died in 1401. At the same time Philip himself, then only eight, had been married to Louis's sister, Michelle. Two years later the second surviving son of King Charles VI of France, John of Touraine, was contracted to Philip's cousin, Jacqueline of Bavaria, and sent to complete his education at her home in Hainault. The direct royal line of France and their Burgundian cousins were thus very closely allied by family ties during the first two decades of the fifteenth century. Marriage had also already created a link between Philip of Burgundy, Henry V and the infant Henry VI, for when Henry married

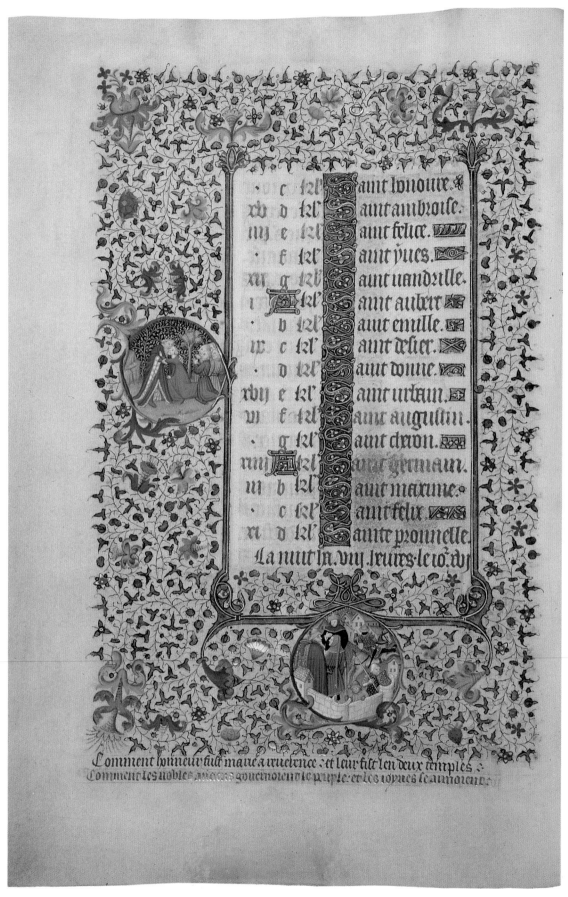

1 Calendar page for the second half of May. Marginal miniatures of (left) the marriage of Honour and Reverence and (below) the state governed by its elders and defended by its youth (f. 5b).

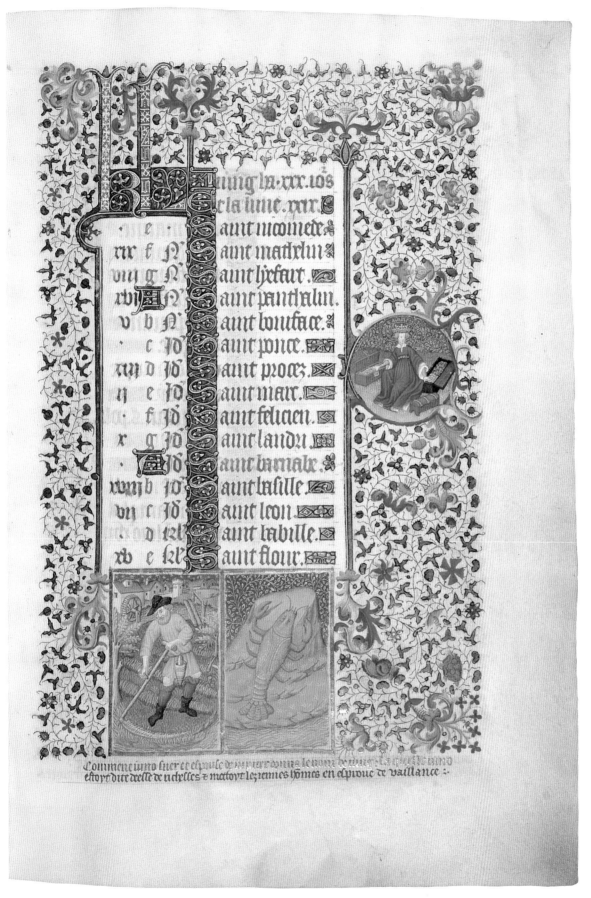

2 Calendar page for the beginning of June. Haymaking and the zodiac sign Cancer. In the margin (right) the goddess Juno for whom the month is named (f. 6).

Catherine of France in 1420, he was marrying the sister of Philip's wife Michelle. Philip was thus Henry VI's uncle by marriage.

By the time of Bedford's marriage in 1423, the earlier Burgundian alliances had disintegrated. Louis of Guyenne had died in December 1415, a few weeks after Henry V's spectacular victory at Agincourt. John of Touraine died in April 1417. Michelle survived until late in 1422, by which time both Henry V and her own father, Charles VI, were dead, and the crown of France had passed into English hands after fundamental changes of position precipitated by the dramatic death of Philip of Burgundy's father, Duke John the Fearless, in 1419. For many years France had been subject not only to the sustained campaign of the English king to support his claim to the French crown but also to a severe internal power struggle between the Burgundian and Armagnac factions. On 10 September 1419 John the Fearless, figurehead of the Burgundian party, went in good faith to meet Charles VI's only surviving son, the Dauphin Charles, who had allied himself with the Armagnacs. They met under conditions of strict security on the bridge at Montereau, and there Duke John was struck down and killed by the Dauphin's men. The full truth about this incident will probably never be known, but the Dauphin was held personally responsible by the Burgundians. The new young Duke Philip was thrown into a fresh and much strengthened alliance with the English king and a direct result was the Treaty of Troyes, recognising the claim of Henry V and his heirs to the French crown and striking the Dauphin from the succession. Thereafter political capital was repeatedly made out of Duke John's death and Philip, who appeared at Henry's wedding to Princess Catherine draped in black from head to foot, apparently favoured black garments for the rest of his life out of respect for his dead father. Soon after the conclusion of the treaty, Philip and Henry together took Montereau from the Armagnacs and, on 24 June 1420, the body of the murdered Duke was raised from its resting place there and taken with all ceremony to the ducal mausoleum at Dijon. Six months later, when the courts were in residence at Paris for Christmas, the absent Dauphin and his associates were formally prosecuted by Nicolas Rolin, afterwards Chancellor of Burgundy, at a *lit de justice* personally presided over by the feeble-minded Charles VI, supported by Henry and in the presence of Philip. The accused were found guilty and convicted of treachery, incapacitating them from holding any office or honour, thus confirming the provisions of Troyes.

A political marriage between one of Henry V's brothers and a sister of the new Duke of Burgundy had been suggested as early as October 1419, during Anglo-Burgundian negotiations preceding the Treaty of Troyes. It became urgently desirable when the death of Charles VI in October 1422 left Bedford Regent of France in the name not merely of its heir but of its new king. Furthermore Bedford was now himself the heir presumptive to a child less than a year old, in an age of widespread infant mortality, and neither he nor his brother Humphrey had children to follow them. Both the continuation of the Burgundian alliance and marriage were vital and a contract promising Anne of Burgundy's hand to Bedford was signed on 12 December 1422. The Treaty of Amiens was concluded on 12 April 1423, a proxy marriage took place five days later, and the formal marriage was celebrated on the Feast of the Ascension. The third party to the Treaty of Amiens, the Duke of Brittany, also arranged to cement the treaty by marriage,

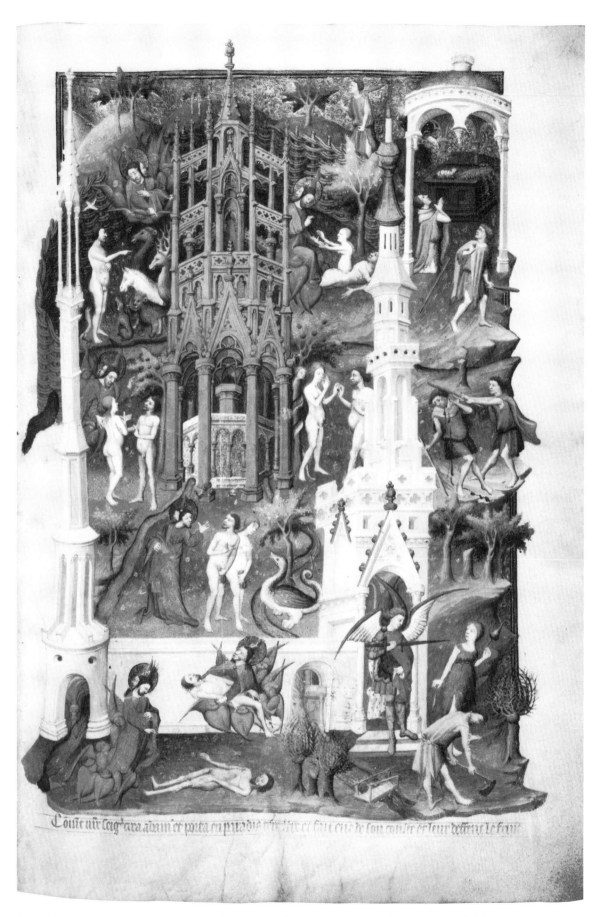

3 Old Testament miniature: the story of Adam and Eve and their sons, Cain and Abel (f.14).

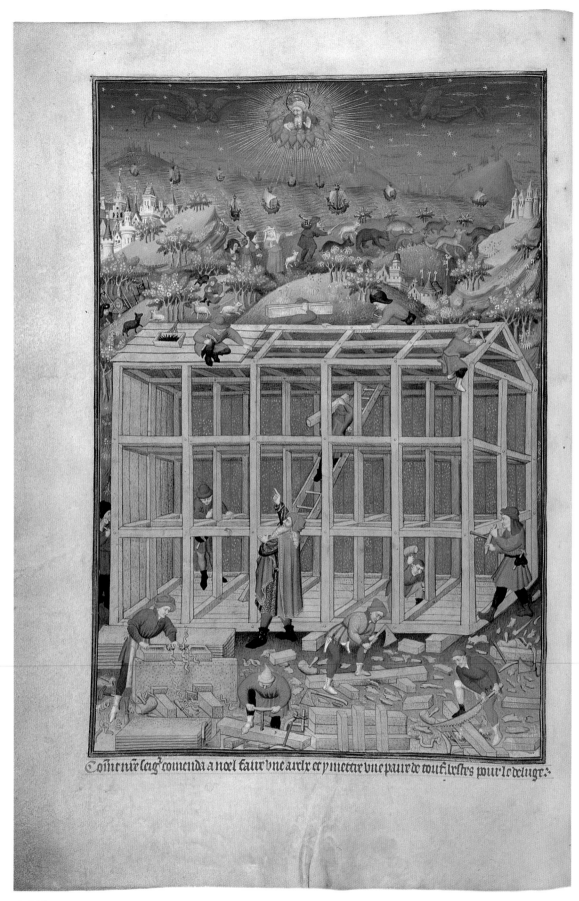

4 Old Testament miniature: the building of Noah's Ark (f.15b).

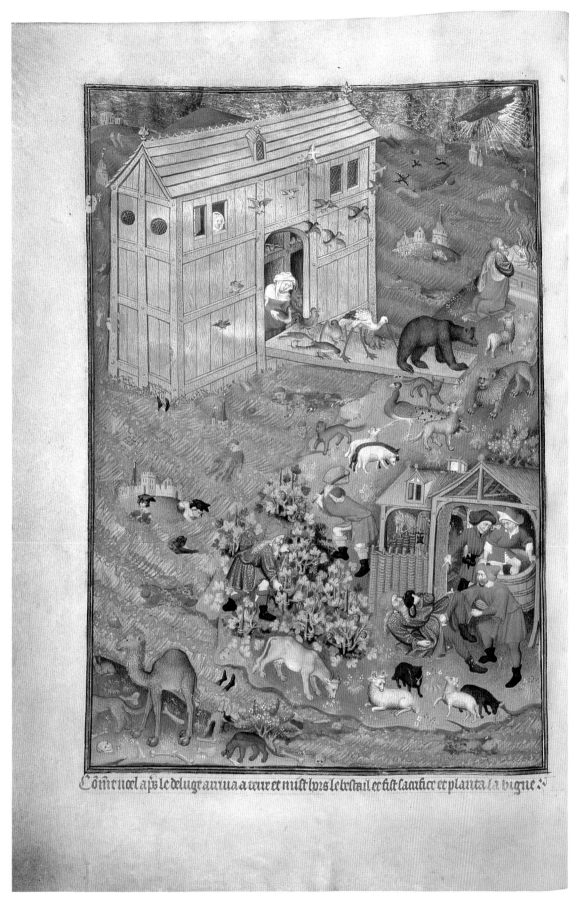

Côme noel a jis le deluge armua a teue et mist hors le vstail et fist sacrifice et planta la vigne

5 Old Testament miniature: the exit from the Ark and the drunkenness of Noah (f.16b).

contracting his younger brother, Arthur of Richmond, to Philip's elder sister Margaret, the widow of Louis of Guyenne. Arthur and Margaret had been childhood playmates, for the Brittany children were brought up in the Burgundy household. This complementary marriage took place in October 1423.

THE BIBLIOPHILE BACKGROUND

It is very fitting that the Bedfords should now be remembered particularly for their association with a fine manuscript. Both the Duke and his Duchess came from families remarkable for their ownership of prestigious illuminated books. John of Lancaster, created Duke of Bedford by his brother, Henry V, in May 1414, was born on 20 June 1389. He was the third of the four sons of Henry of Bolingbroke, heir of John of Gaunt and his wife, Blanche of Lancaster, who ousted Richard II in the autumn of 1399 and was crowned Henry IV. Bedford's mother was Mary Bohun, Henry's first wife and the wealthy co-heiress of Humphrey, Earl of Hereford. She, her husband and her father are all associated with lavishly illuminated liturgical manuscripts in the 'Bohun' style, made during the second half of the 14th century by a small group of English artists who were apparently employed directly by the Bohun family. Mary died in 1394, aged about 24 years old, and the upbringing of her children was influenced by their grandmother Joan, Dowager Countess of Hereford, who was also a book lover and who seems to have owned, among other treasures, the celebrated Luttrell Psalter (British Library, Add. MS 42130). In later life all Mary Bohun's sons developed a taste for fine books and the youngest, Humphrey, Duke of Gloucester, is remembered as the founder of Oxford's Bodleian Library.

The Burgundy family were even more prominent as book collectors. The Duchess of Bedford's grandfather, Philip the Bold (d.1405), was a brother of Charles V of France and of the Duke of Berry, both of whom were among the greatest bibliophiles of all time. Philip himself and his son, John the Fearless, were both noted lovers of luxury illuminated manuscripts, and Anne's own brother, Philip the Good, was to amass one of the greatest libraries of 15th century Europe.

At the time of the marriage Bedford himself already owned at least one superb illuminated liturgical book, the stately Psalter and Hours commissioned for him from the English workshop of Herman Scheerre (British Library, Additional MS 42131). This manuscript, which was entirely unknown before 1928, can be dated between 1414, since it already refers to its patron as Duke of Bedford, and 1423, as there is no mention of his wife. After the marriage he commissioned two further manuscripts from the Parisian craftsmen responsible for the Bedford Hours. One, an extremely rich and elaborate Breviary, is now MS lat. 17294 in the Bibliothèque Nationale in Paris. The other, commonly called the Pontifical of Poitiers, was most unfortunately destroyed during the siege of Paris in 1871. Both books contained extensive evidence, largely heraldic, of their connection with Bedford and Duchess Anne. Both must have been designed for use in their private chapel. However, neither of these immensely costly books was completed in Bedford's lifetime, though the commissions imply that the Duke was fully aware of the prestige value of being seen to own magnificently decorated liturgical manuscripts.

THE DESIGN AND CONTENTS OF THE BEDFORD HOURS

The Bedford Hours, which measures 260×180mm (10½×7⅛ inches), presents a picture of expertly planned and professionally executed regularity. The body of the book falls into six unequal sections, each of which comprises a coherent sequence of devotions appropriate to inclusion in this type of book. Each section is composed of multiple gatherings of eight leaves. These sections are preceded by one gathering of twelve leaves, carrying the calendar, and interrupted by three small irregular groups of folios devoted to special materials, mainly full-page miniatures not directly related to the standard text. These include the portraits of the Duke and Duchess (figs. 43 and 47). An outline of the structure and contents of the manuscript is given on p. 63.

The text includes extracts from the Four Gospels, the Hours of the Virgin according to the use of Paris, the Penitential Psalms, special Hours assigned to each of the seven days of the week, the Office of the Dead, the Hours of the Passion, Memorials of selected saints, and a number of separate special devotions. Each of the thirty-one major divisions of the text is marked by a large miniature of an appropriate subject, its surrounding border including roundels which enclose smaller scenes or figures relating to the subject of the main miniature. All these large miniature pages are reproduced here, in the sequence in which they occur in the manuscript (fig. 8 onwards).

The anonymous principal artist, who was later to play a major role in the production of Bedford's two other grand liturgical books, is known as the Master of the Duke of Bedford from his involvement with this particular patron. He seems to have been at the head of a major illuminating business in Paris during much of the first half of the 15th century and a substantial number of luxury manuscripts is attributed to him and his associates. Of special relevance to any discussion of the contents and decoration of the Bedford Hours are two other manuscripts from the same circle, now in Lisbon (the Lamoignon Hours, formerly in the collection of the Dukes of Newcastle and now in the Gulbenkian Foundation) and in Vienna (Österreichische Nationalbibliothek, MS 1855). These two books are very similar in format to the Bedford Hours and the majority of their main miniatures, together with the subsidiary roundels in the borders of the miniature pages, are clearly derived from the same models. This helps us to distinguish which elements in the Bedford manuscript are unique to that book.

Of the basic contents of the manuscript, the most unusual element appears to be the Hours of the Passion with its accompanying picture cycle. Other Bedford Master manuscripts do include these Hours. A fine Hours in Yale (the De Lévis Hours, Yale MS 400 in the Beinecke Library), slightly earlier in date than the Bedford Hours, retains five of an original series of eight miniatures illustrating this office, and these are clearly related to the Bedford series. There are miniatures for the Hours of the Passion in the Hours of Jean Dunois, which was probably made about 1440 (British Library, Yates Thompson MS 3). The Sobieski Hours in the Royal Library at Windsor, which was initiated by the Bedford Master but which includes work by several other very distinct hands, offers a sequence of full-page compositions in each of which several episodes of the story are brought together. The Bedford picture cycle is distinguished in two ways.

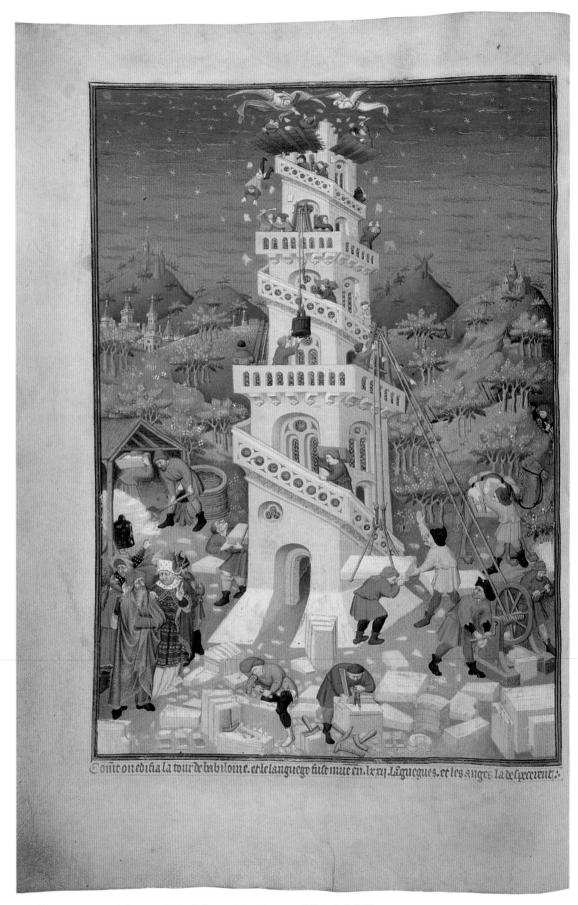

Comt onedifia la tour de babiloine. et le languege tutt mue en lxxij. languegues. et les anges la defpeceurt.

6 Old Testament miniature: the building of the Tower of Babel (f.17b).

7 'Obsecro te': historiated initial of the Virgin and Child. Marginal miniatures from the *Speculum* cycle showing (right) the Presentation of the Christ Child and (below) its prefiguration, the entry of the infant Samuel into the Temple (f. 25).

In the first place each of the main miniatures (figs. 8–42) is accompanied by an unusually elaborate set of marginal roundels, including such episodes as Peter's denial (fig. 36), Pilate's wife's dream (fig. 39), Joseph of Arimathea begging Christ's body from Pilate (fig. 41) and the Jews urging Pilate to place a guard upon the tomb (fig. 42). In many instances the name of a character or the words being spoken are supplied on a scroll, adding to the observer's general feeling of participating in a drama. In the second place the cycle opens not with the more or less standard scene of the Betrayal but with Christ praying on the Mount of Olives (fig. 35), beholding all the scenes of the forthcoming Passion etched upon the sky. It may be recalled that the principal relics of the Passion were among the treasures enshrined by St Louis in the Sainte Chapelle in Paris. It was the custom for the king of France to display these to the people on Good Friday and this was one of the duties which Bedford as Regent undertook in the name of Henry VI. It is also worth noticing that the central Crucifixion scene of the Passion cycle (fig. 40), which would have duplicated the Crucifixion already supplied to introduce the Hours of the Cross (fig. 30), is transformed by written scrolls into an image of the Seven Words from the Cross, as the two lines of commentary at the foot of the page explain. Each of the manuscript's main miniatures, except for the Annunciation (fig. 12) and the Death of the Virgin (fig. 21), is supplied with a similar short commentary, in French, identifying the subjects on the page. These 'subtitles' are written in blue and red, to distinguish them from the lines of blue and gold text which are found accompanying the marginal decoration on the text pages of the manuscript.

THE ARMORIALS

The armorials of the Duke and Duchess of Bedford occur seven times in the manuscript, in addition to the arms and devices found on the portrait pages (figs. 43 and 47). The first and grandest example appears as a whole page composition among the Old Testament miniatures which form the first of the three groups of leaves inserted into the basic structure of the manuscript. This is now overpainted with the arms of Henry II of France and his queen, Marie de' Medici, who owned the manuscript in the 16th century. The other six are all found as decorative panels below the last lines of text in individual sections of the book. As the first section, the twelve-leaf gathering containing the calendar, presents no suitable space, an additional panel is placed among the gospel extracts. An example is reproduced as fig. 46. In each case the two coats of arms appear side by side. The Duke bore the royal arms of England, suitably differenced, and these are surrounded by the golden roots which were his personal badge (adopted when he became Regent of France, apparently to reflect the rebus of Edward of Woodstock, the Black Prince) and accompanied by his motto 'a vous entier'. The Duchess bore her husband's arms impaling those of her father, the Duke of Burgundy, surrounded by her badge of the yew branch (perhaps in reference to her grief for the death of her father) and accompanied by her motto 'jen suis contente .y. '. The 'y' is probably a reference to her husband's initial as the monogram of 'a' and 'y' occurred with the root badge in the marginal decoration of the now destroyed Pontifical of Poitiers.

8 Gospel extracts: St John the Evangelist, with marginal scenes from his life (f.19).

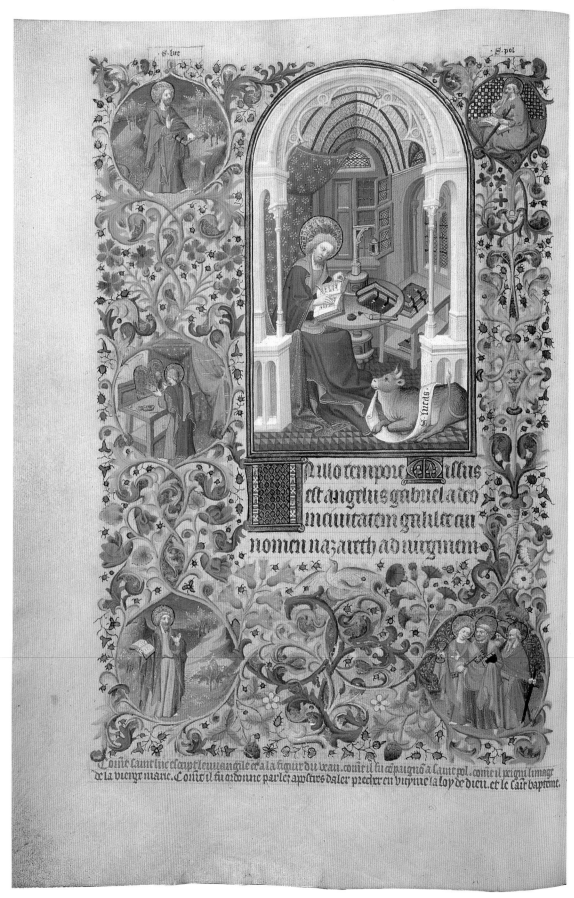

9 Gospel extracts: St Luke the Evangelist, with marginal scenes from his life (f. 20b).

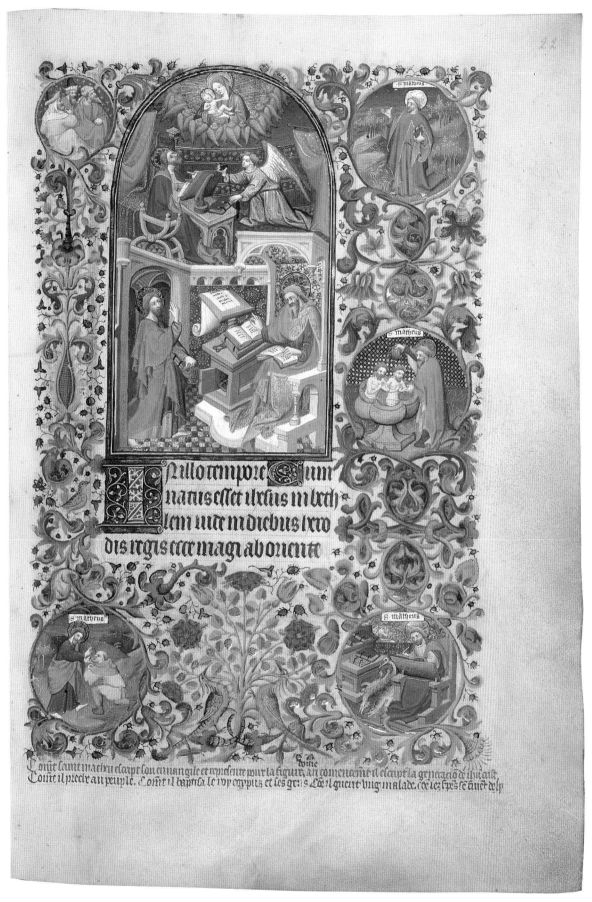

10 Gospel extracts: St Matthew the Evangelist, with marginal scenes from his life (f. 22).

The workshop seems to have been instructed to punctuate the Bedford Hours with armorials at the end of each coherent section and suitable spaces below passages of text elsewhere in the manuscript are ignored. It has been suggested that the choice of position, in spaces at the ends of pages of text rather than among the marginal decoration beneath miniatures introducing important devotions, must indicate that the armorials are additions to the original design of the book, implying that the volume need not have been made specifically for the Bedfords but merely adapted for them. However, a quick survey of other French manuscripts of the period reveals that there was in the early 15th century no standard position for the insertion of a patron's arms. A majority of the most costly illuminated devotional books of the time, including the Lisbon and Vienna Hours, contain no arms at all. At the other extreme, the most heavily personalised Hours of the period, the Hours of the Maréchal de Boucicaut in the Musée Jacquemart André in Paris, confines its patron's arms and devices to the background elements of its full page miniatures and to its initials. Later books from the Bedford Master workshop, including the Duke's own Breviary, do place armorials within the border ornament below the principal miniatures and this practice became more or less standard in manuscripts made later in the 15th century. Familiarity with these has come to imply that they represent a norm for earlier periods. There is one other indication of Bedford ownership within the body of the manuscript; in the decoration surrounding the miniature of the Last Supper (fig. 29) the mottoes of the Duke and Duchess appear, written on red, white and blue scrolls. That these have been altered in some way is clear, but even microscopic examination does not reveal how they originally appeared.

THE MARGINAL SCHEMES

The marginal decoration of the Bedford Hours is unusually rich and original, comprising well over a thousand small circular miniatures in addition to the roundels specifically designed to accompany the thirty-one principal miniatures. Each roundel is little more than an inch in diameter. One main cycle runs through most of the text pages of the book, and the calendar has a scheme of its own.

The Bedford calendar has a strong classical flavour, in contrast to the calendar schemes in the Vienna and Windsor Hours, which both employ a sequence of Prophets and Apostles representing the twelve articles of the Apostles' Creed. In the Bedford Hours each month occupies the recto and verso of a single leaf. In the lower margin of the recto the appropriate labour of the month and its accompanying zodiac sign are shown and in the right-hand margin of the same page there is a roundel containing a figure or figures representing the derivation of the name of the month (figs. 48 and 49). On the verso two further roundels show events characteristic of the month or in some way connected with it (half title, title verso and back cover). The subjects of the roundels, but not the labours and the zodiac signs, are explained in blue and gold 'subtitles' at the bottom.

The calendar pages for the end of May and the beginning of June are reproduced (figs. 1 and 2). May is associated with a marriage between Honour and Reverence, and with the government of the state by its elders and its defence by the young. On the verso of the

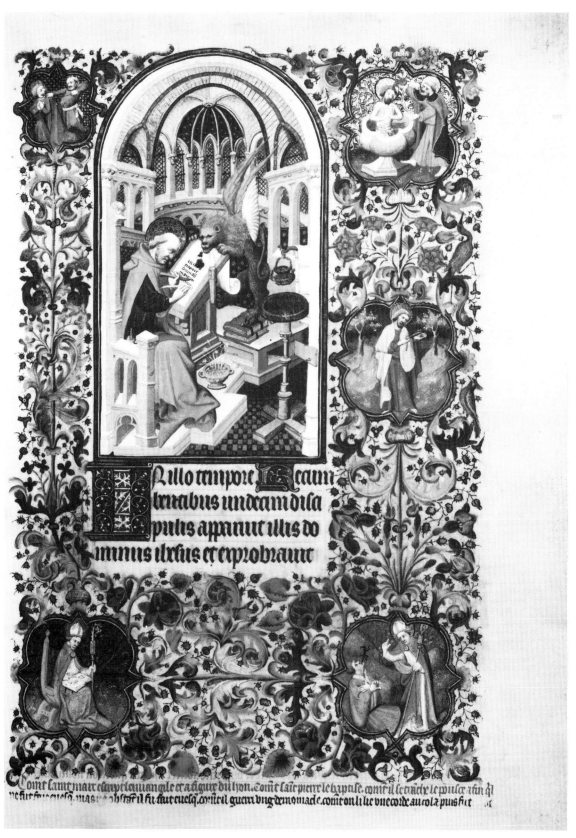

11 Gospel extracts: St Mark the Evangelist, with marginal scenes from his life (f. 24).

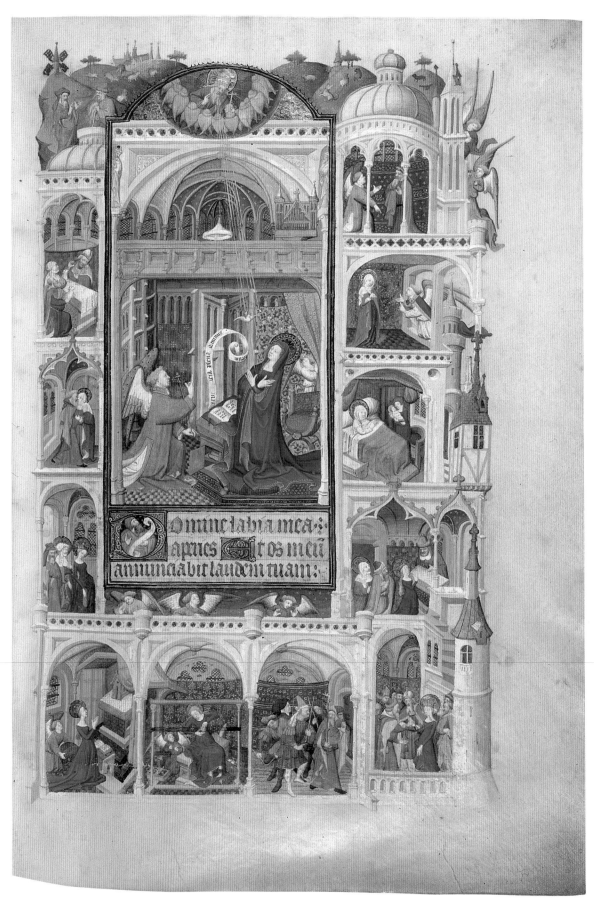

12 Hours of the Virgin (Matins): the Annunciation, with scenes from the early life of the Virgin Mary (f. 32).

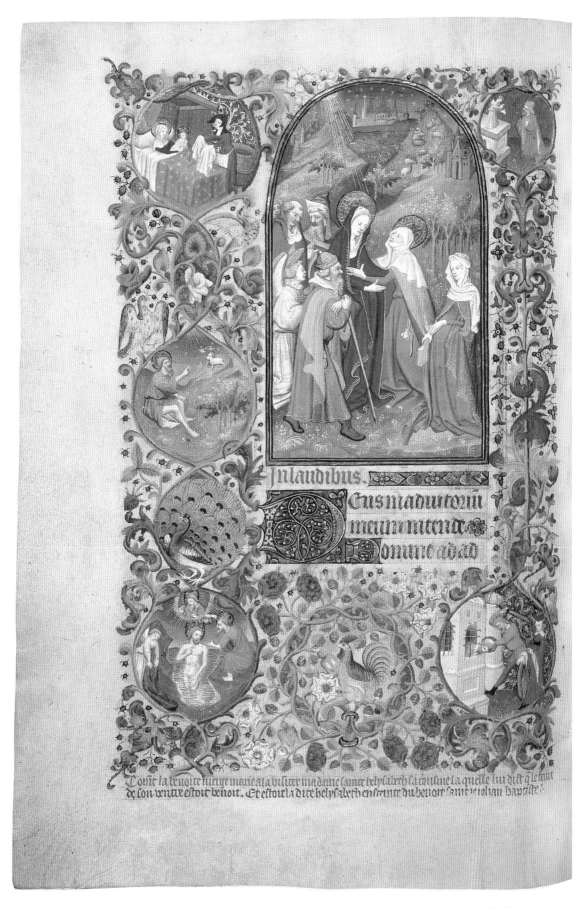

13 Hours of the Virgin (Lauds): the Visitation, with scenes from the life of John the Baptist (f. 54b).

June leaf are roundels representing the marriage of Hercules and Hebe, and the alliance between Romulus and Tatius. It is tempting to connect these references with the recent true-life associations of these two months, which witnessed the Treaty of Troyes between Henry V and Charles VI on 21 May, the marriage of Henry and Catherine of France on 2 June, and the Bedfords' own marriage on 13 May.

The marginal decoration of the text pages through almost the entire length of the book, from the beginning of the Hours of the Virgin to the end of the Hours of the Passion, is devoted to a single coherent scheme. This covers the whole of the New Testament, each episode accompanied either by its Old Testament prefiguration or by some form of pictorial commentary. The vast scope of this programme is so daunting that it has yet to be studied in full detail. It may most simply be categorised as an elaborated version of the popular *Speculum Humanae Salvationis*. The reader's understanding is aided by explanatory 'subtitles' written, like those of the calendar pages, in blue and gold. The sequence is broken at each main miniature page where, as we have seen, the 'subtitles' are in blue and red. Examples from the scheme may be seen in figs. 14, 15, 25, 26, 44 and 45. The programme ends before the Memorials of the Saints begin at f. 260, after which the marginal roundels are related to the adjacent text (figs. 50 and 52).

The New Testament scheme has two breaks in addition to those dictated by the main miniature pages. A whole gathering, ff. 160–167, seems to have been overlooked while the work was in progress. The previous gathering ends with the Epistle of Paul to Philemon, the following one continues with his Epistle to the Hebrews. There are signs that the borders of the intervening leaves were originally filled up completely with pure decoration. This clearly advertised the mistake too obviously, so spaces for roundels were rather crudely scrubbed out and a makeshift sequence devised, painted by one of the

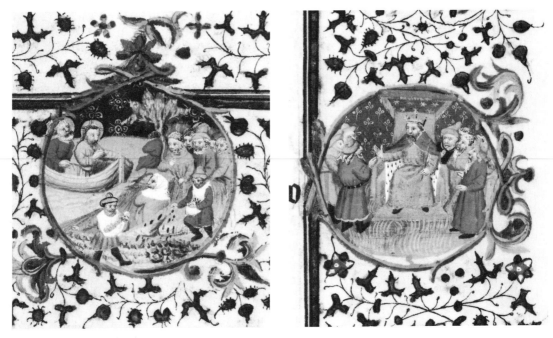

14 (*left*) Marginal roundel: Christ relating the parable of the sower (f. 46 detail).
15 (*Right*) Marginal roundel: King David telling his servants that he speaks in parables (f. 46 detail).

inferior hands. The first twenty-four of its thirty-two roundels enclose figures of the Prophets and Apostles, representing the articles of the Creed as seen in the Vienna and Windsor calendars. The remaining spaces are filled by the figures of good and bad rulers: David (who 'par la volente de dieu fust bon roy et devot et conquist le pais de israel'), Solomon, Constantine, Justinian, Roboam (who 'par sa folie en ieus et autres sotises' lost his kingdom), Nicephorus (who 'fust jeune et prince de petit gouvernement et perdit sa seigneurie'), Josia (who 'restaura le royaulme de iherusalem et de iudee et fist garder la loy') and Charlemagne (who 'pensant en dieu preposoit a guerroier les sarrasins et mescreans'). These seem likely to have been chosen for their political relevance as possible parallels to contemporary rulers. It is interesting to note that all the good rulers occur also among the heroes and kings whom little Henry VI was urged to emulate in the ballad which Lydgate addressed to him at the time of his English coronation in 1429. In view of the fact that Henry V died lamenting his failure to lead a new crusade and with a history of the crusades at his side, it is also interesting to note the characteristics attributed to Charlemagne, one of the chief patrons of France.

The second intrusive sequence comes on ff. 253b–255b, where five pairs of roundels remained empty at the end of the Apocalypse illustrations. These too seem to have been filled with an eye to contemporary political relevance. Their 'subtitles' are worth quoting:

f. 253b: 'Comment cayn occit abel son frere le quel estoit bon et iuste et faisoit a dieu bon et agreable sacrifice:
Comment abraham voult sacrifier ysaac son filz pour lamour de dieu mais lange le deffendist.'

f. 254: 'Comment iepte sacrifia sa fille pour lamour de dieu sur lautel en la presence de plusieurs notables gens:
Comment ioab tua abner en traison en un hostle en la presence de toutes leurs gens et estoient tous ii conestables.'

f. 254b: 'Comment ioab tua amassa par traison en le baisant et estoyent tous deux grans officiers subgies a i roy:
Comment le roy de egypte occit iosie le bon roy de iherusalem en pleine bataille a force de gens darmes.'

f. 255: 'Comment les senateurs de romme occirent et mistrent a mort iulius cesar le quel estoit au conseil:
Comment tholome duc de iherico occit en traison symon machabee grant prestre des iuifs et seigneur de iherusalem en disnant.'

f. 255b (fig. 46): 'Comment aristobole fist mourir anthoigne son frer le que il avoit mande quille venit veoyr en sa maladie:
Comment david fist sollempnelement enselevir abner qui estoyt prince de la chevalerie de iherusalem.'

The repeated references to treason, to the presence of many witnesses, and to equality of rank between murderer and victim, together with the final reference to the raising of Abner's body by David, suggest that these scenes were contrived with the very deliberate purpose of reminding the owner of the Bedford Hours of the recent events at Montereau. King Charles VI had thereafter sacrificed his own son—or at least, committed him to exile and the loss of his filial rights—in a very public manner, and no angel had come forward to champion his innocence.

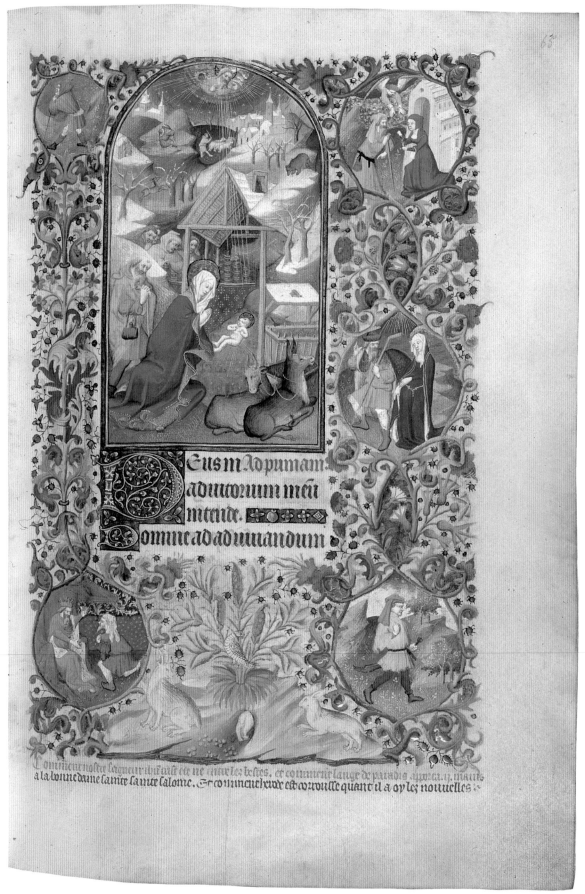

16 Hours of the Virgin (Prime): the Nativity, with scenes from the Christmas story (f. 65).

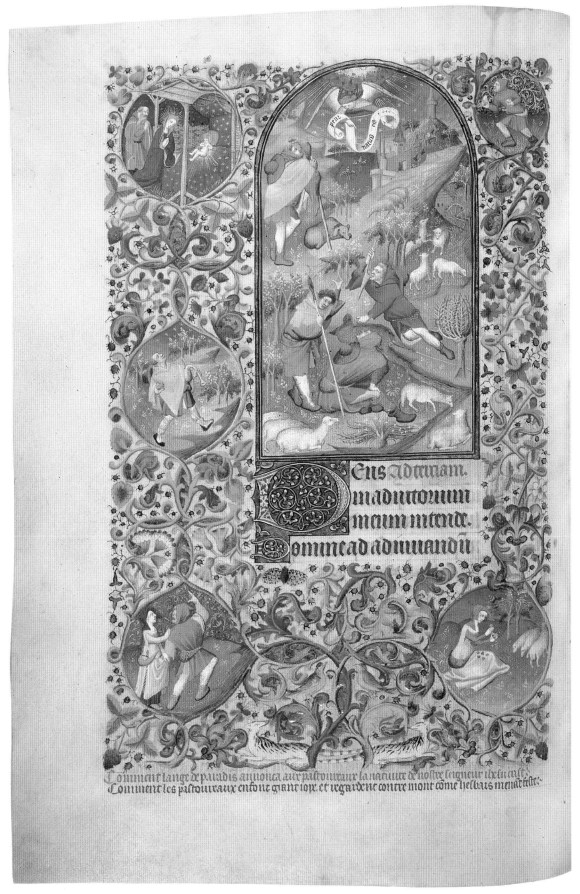

17 Hours of the Virgin (Terce): the Annunciation to the Shepherds, with the Holy Family and figures of shepherds and shepherdesses (f. 70b).

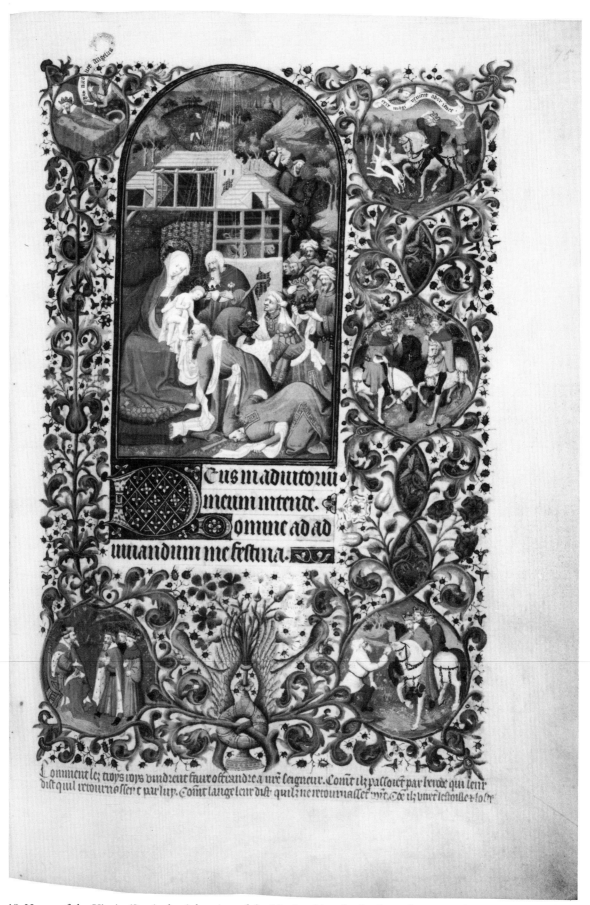

18 Hours of the Virgin (Sext): the Adoration of the Magi, with episodes from the story of their journey (f. 75).

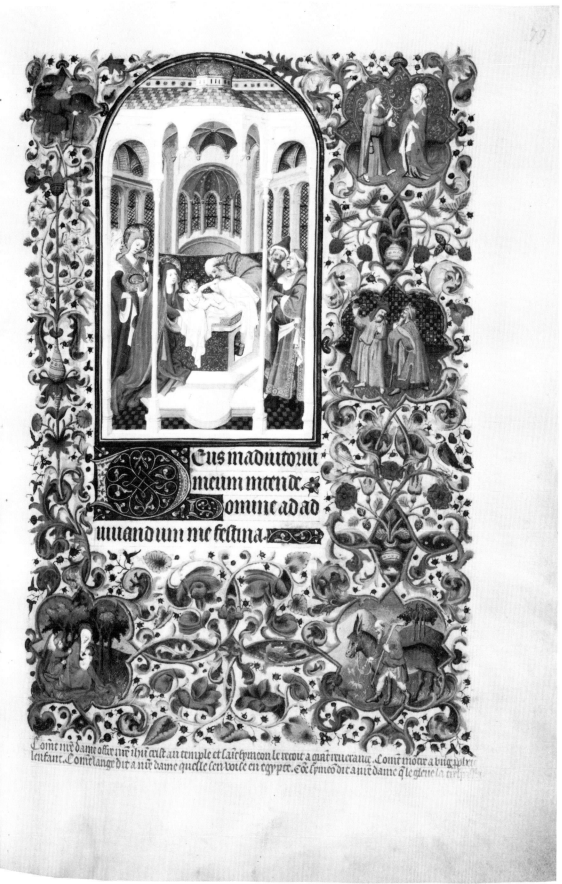

19 Hours of the Virgin (None): the Presentation, with the story of Simeon and episodes from the journey into Egypt (f. 79).

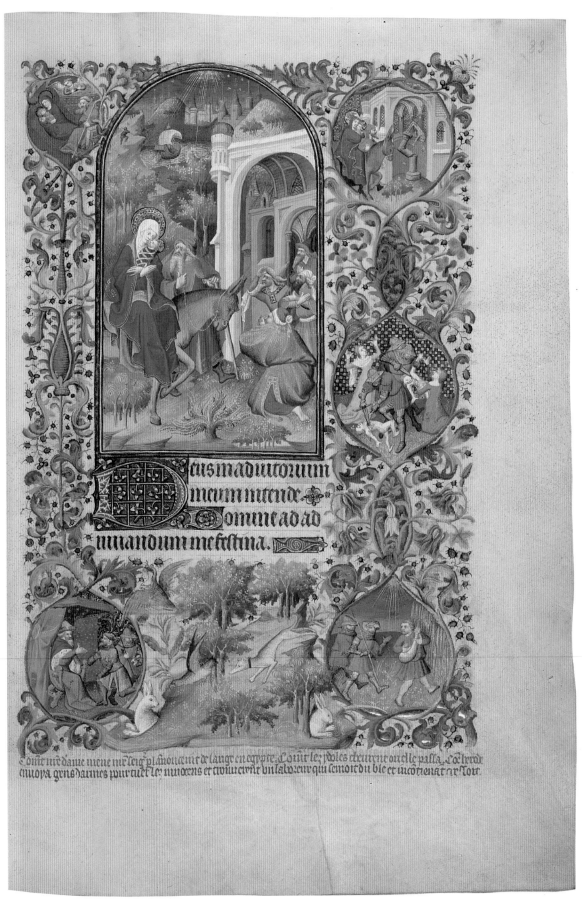

20 Hours of the Virgin (Vespers): the Arrival of the Holy Family in Egypt, with further episodes from their journey and from the massacre of the innocents (f. 83).

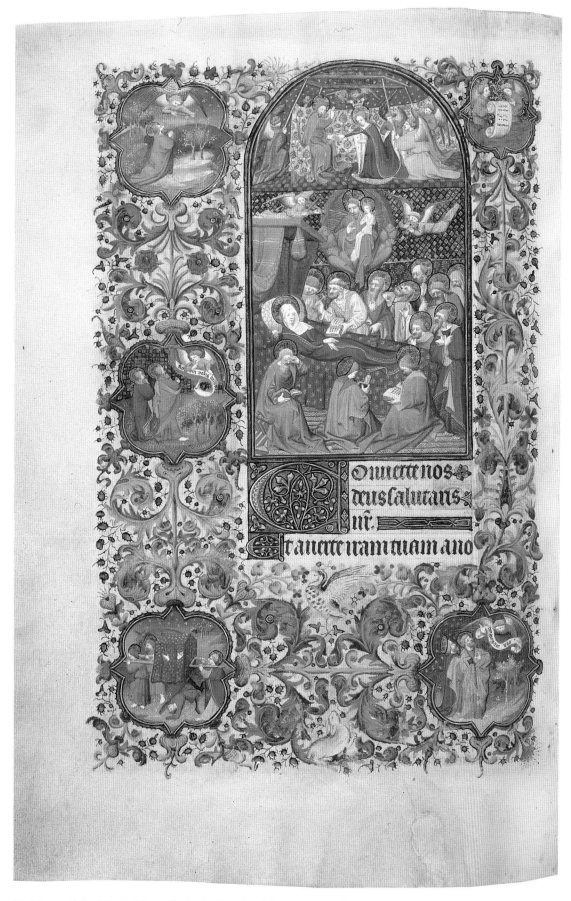

21 Hours of the Virgin (Compline): the Death of the Virgin, with scenes of the gathering of the Apostles and of her funeral (f. 89b).

The Bedford Hours is not unique in including an elaborate independent marginal programme. Two more or less contemporary manuscripts from the workshop of the Master of the Rohan Hours have similar, though less ambitious, embellishments. One is a cycle from the *Bible moralisée* and the other follows Deguilleville's *Three Pilgrimages* and the Apocalypse. It is clear that a number of artists participated in the production of the Bedford cycle, and detailed study could provide additional information about the Bedford Master's working arrangements.

THE OLD TESTAMENT MINIATURES

The first of the three irregular groups of leaves inserted into the body of the manuscript is placed between the calendar and the beginning of the text. It carries a sequence of four full-page illustrations of Old Testament subjects which at first sight seem entirely out of place within a Book of Hours. Only the first of the four, depicting the stories of Adam and Eve and their sons, Cain and Abel (f.14; fig. 3) is in the style typical of the Bedford Master himself. The other three, the Building of Noah's Ark (f.15b; fig. 4), the Exit from the Ark and Noah's Drunkenness (f.16b; fig. 5), and the Building of the Tower of Babel (f.17b; fig. 6) are by another, though related hand (that of an associate of the Bedford Master, known as the Master of the Munich Golden Legend) and are rather differently conceived, being rigidly confined within their frames rather than extending into the margins. They are accompanied only by single line 'subtitles' written in blue. However, each is followed by a blank page and it is very likely that they should have been provided with elaborate explanatory texts. The inclusion of the Bedford armorials on the odd blank page within this group of leaves confirms that they are part of the original scheme.

With the identification of the marginal cycle as coming from the family of the *Speculum Humanae Salvationis*, a reason for the presence of these pictures appears. Copies of that work commonly begin with illustrations representing the Fall of Man, from which the events chronicled in the New Testament redeemed him. The subjects are usually confined to the stories of Adam and Eve and Noah. However, the Tower of Babel, commonly seen as a foreshadowing of the gift of tongues at Pentecost, readily fits the same pattern and the Bedford marginal cycle does include the mission of the Apostles as well as the Life of Christ.

THE LEGEND OF THE FLEURS DE LYS

The last of the three insertions consists of just two leaves placed at the very end of the manuscript. The subject matter of this insertion is narrative rather than devotional, telling, in a full-page illustration accompanied by thirty lines of French verse, the story of the heavenly gift to Clovis of the device of the three fleurs de lys, the royal arms of France. The miniature (f.288b; fig. 51) is by the associate of the Bedford Master who painted the Noah and Babel miniatures for the beginning of the book and is, like them, presented within a rectangular frame. It shows the Almighty dispatching an angel to

entrust the fleurs de lys to the hermit of Joyenval who, in his turn, hands them to Clovis's wife, Clothilda. At the focal point of the picture she presents them, in the form of a shield, to her husband, who is newly converted into a Christian knight.

The story of Clovis was much favoured by the Dukes of Burgundy, for Clothilda was a Burgundian princess. The legend could therefore be used as an allegory to underline the vital importance of their support to any claimant to the French crown at the beginning of the 15th century. There are several references to tapestries of the subject and it is particularly interesting to note that Duke John the Fearless presented one to his son-in-law Louis of Guyenne, Charles VI's heir, though unfortunately there is no record of how the story was treated on it. In the miniature there seem to be direct references to Burgundy. As Clothilda hands over the shield to Clovis, she is assisted by a male figure wearing a rather noticeable hat of green, white and black, apparently identifiable as the livery colours of the Dukes. A tiny shield over the gateway of the building in which the event is taking place is charged with the lion of Flanders. These hints can be construed as references to the part played by Duke Philip in supporting Henry V at the time of the Treaty of Troyes, as a result of which the English king did in effect receive the fleurs de lys through his marriage to Catherine of France. But the same hints are perhaps even more relevant in the context of Bedford's own marriage, for his custody of the fleurs de lys was supported by union with a contemporary Burgundian princess, Anne herself. According to the accompanying verses, which are elegantly written out in the same blue and gold as the 'subtitles' to the marginal cycle, Clovis was receiving his new arms to announce his election as 'constable', with the blessing of the Holy Trinity, in order to establish the faith and overcome iniquity. In both France and England the title of constable was a familiar and specific one, denoting the commander-in-chief. Bedford had been created Constable of England by his father, Henry IV, as early as 1403. The military responsibilities which the title implies for France were certainly applicable to Bedford at the time of his marriage, when his mission was indeed to establish the faith, in the sense of the provisions of the Treaty of Troyes (?trois), and to suppress iniquity as personified by the Dauphin and his Armagnac allies.

The legend of the fleurs de lys remained a popular theme and was twice exploited by Lydgate about the time of Henry VI's English coronation in 1429, once in the ballad addressed to the child king and once in a mumming for Christmas. The specifically Burgundian references are however lacking from Lydgate's works, which instead appear to equate the king's mother, Catherine of France, with Clothilda, who was of course one of her legendary ancestresses.

THE PORTRAITS OF THE DUKE AND DUCHESS OF BEDFORD

The remaining inserted group of leaves consists of four folios (ff. 256–9) placed at the beginning of the last main section of the manuscript, which contains memorials of the saints and special masses. No large miniature was provided for to introduce this section, so a specially designed representation involving the patron or patrons was obviously

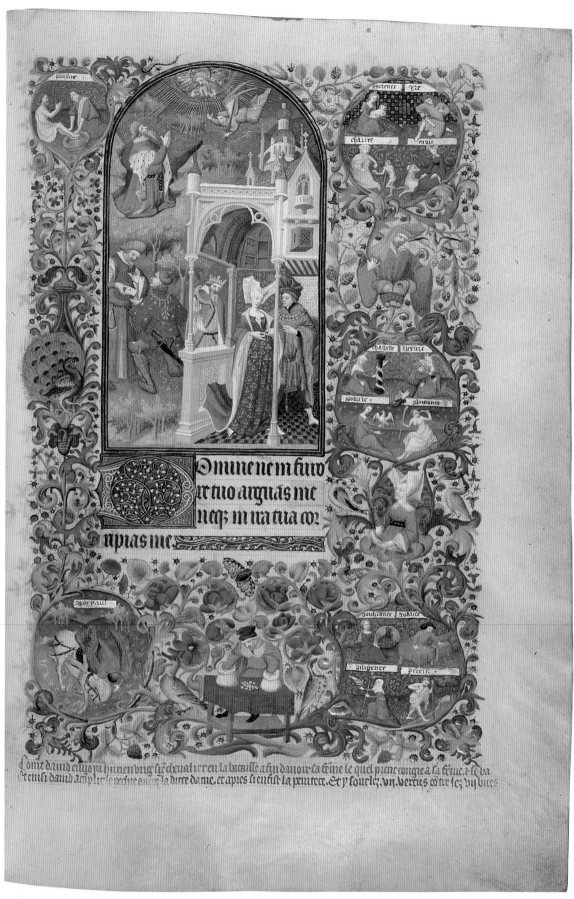

22 The Penitential Psalms: the story of David and Bathsheba, with marginal roundels of the Virtues and Vices (f. 96).

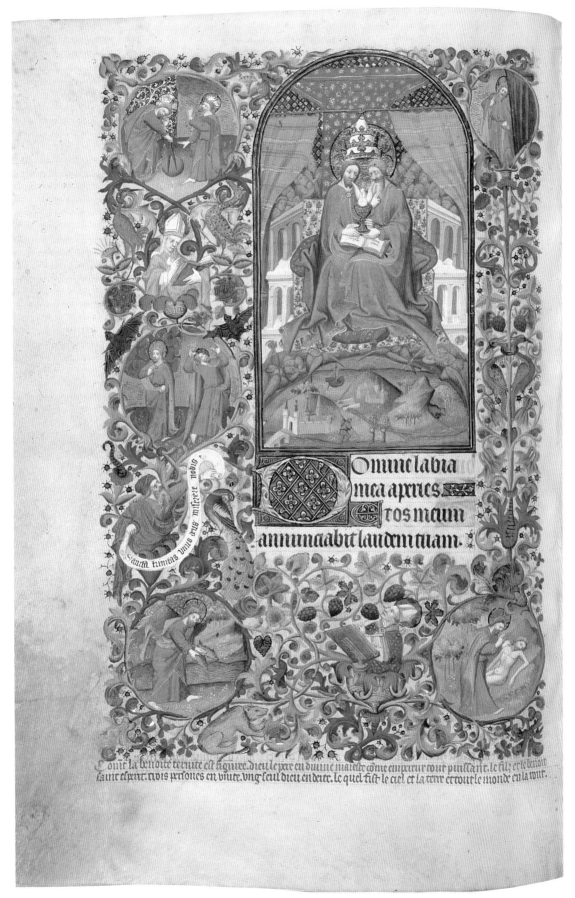

23 Hours of the Trinity (for Sunday): the Holy Trinity, with scenes of the Creation (f.113b).

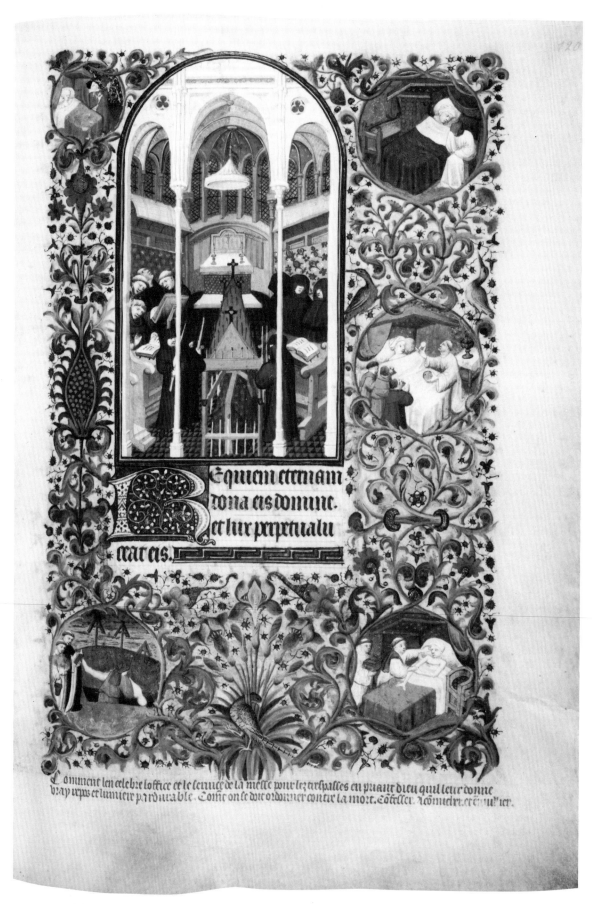

24 Hours of the Dead (for Monday): a requiem, with scenes of the last rites (f.120).

always intended. The inserted leaves carry the famous portraits of the Duke (f.256b; fig.43) and of the Duchess (f.257b; fig.47), accompanied by patron saints and with appropriate accompanying prayers.

Anne of Burgundy appears kneeling before her patron and namesake, St Anne, mother of the Virgin Mary. The saint is accompanied by the Virgin, shown as a little girl whom she is teaching to read, and the Infant Christ. The figure standing behind the Duchess's chair, on the framework of which is a tiny shield of the arms of Burgundy, may be intended to represent Joseph. In the margin to the left of the miniature are the three husbands of St Anne, Joachim (father of the Virgin), Cleophas and Salomas, and at the foot of the page are her other daughters, Mary Cleophae and Mary Salomae, with their husbands, Alpheus and Zebedee. Mary Cleophae's sons, James, Simon, Jude and Joseph the Just are depicted in the margins on f.258 and Mary Salomae's sons, James and John, occupy roundels on f.258b. All the supposed members of St Anne's family are identified by inscriptions, somewhat clumsily executed. Although the appearance of these characters is entirely in accordance with contemporary piety, and a similar composition was later included in the Bedford Breviary, the stress on family relationships is peculiarly appropriate to Anne, given the long catalogue of diplomatically significant marriages within her immediate family circle. Her personal arms, motto and yew branch badge are incorporated at various places in the design of the page.

John of Lancaster is portrayed not with his personal patron, St John the Evangelist, but with St George, who had been especially venerated by his brother, Henry V, and who was patron of England and of the Order of the Garter. His appearance in this context is undoubtedly designed to underline Bedford's status as Regent. Tiny shields of the arms of England are placed in the windows at the back of the composition. The saint himself is shown, uniquely, wearing the ermine-lined sovereign's robe of the Order of the Garter

25 Marginal roundel: the parting of Paul and Barnabas, the former to go to Syria, the latter to sail to Cyprus (f.125 detail).

26 Marginal roundel: the parting of Abraham and Lot, the latter to journey to Sodom (f.125 detail).

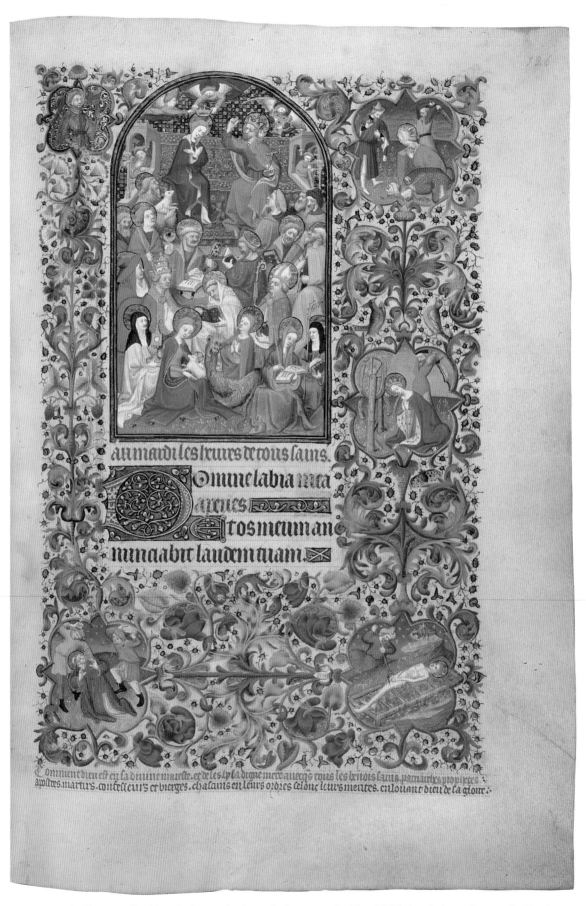

27 Hours of All Saints (for Tuesday): a gathering of saints, mostly identifiable by their attributes. Sts Denis, Catherine, Lawrence, Stephen and George are placed in the marginal roundels (f.126).

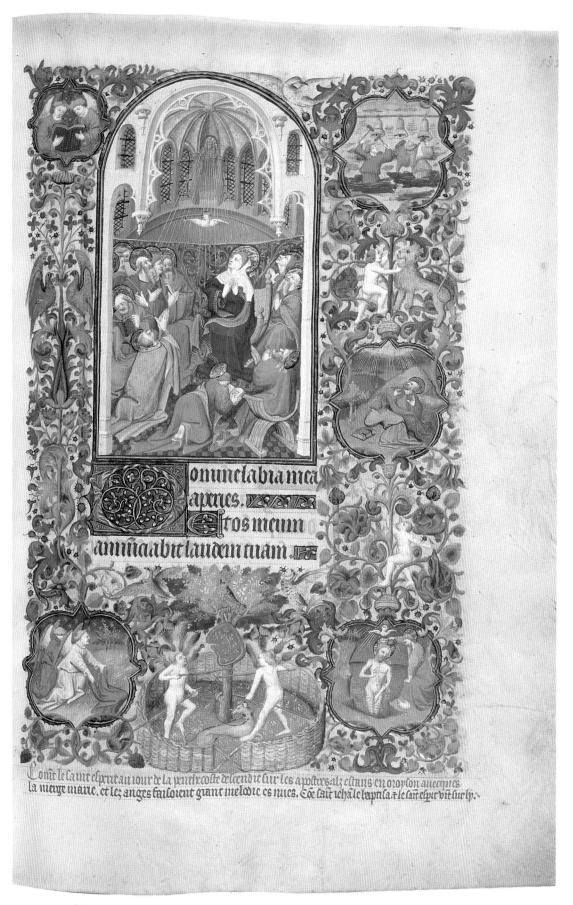

28 Hours of the Holy Ghost (for Wednesday): Pentecost, with rejoicing angels and scenes of the baptism of Christ (f.132).

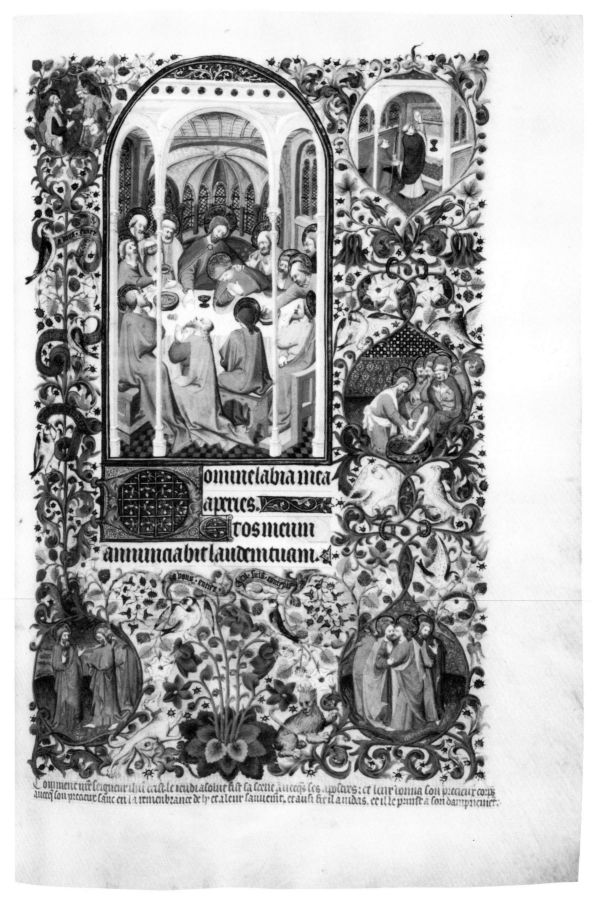

29 Hours of the Holy Sacrament (for Thursday): the Last Supper, with a priest at Mass, the Washing of the Disciples' Feet, and the story of Judas (f.138).

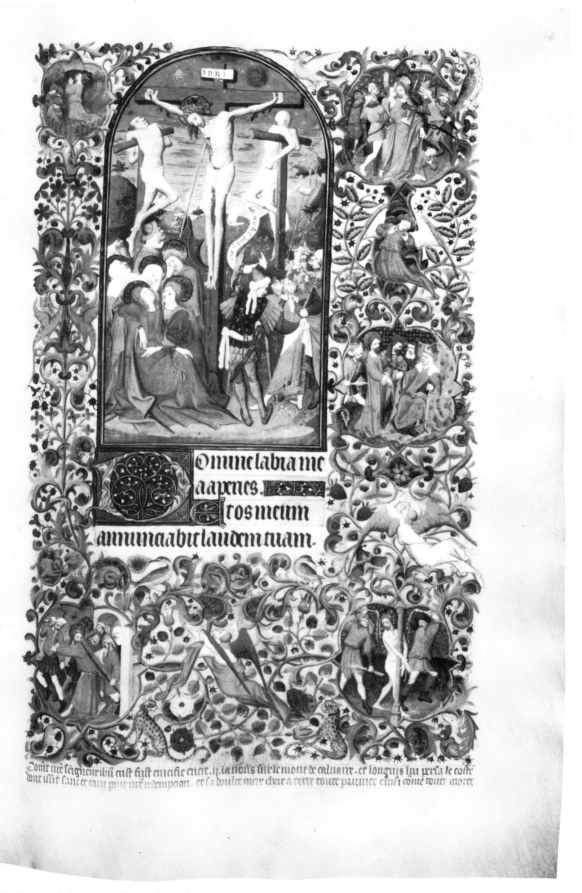

30 Hours of the Cross (for Friday): the Crucifixion, with scenes from the Passion story (f.144).

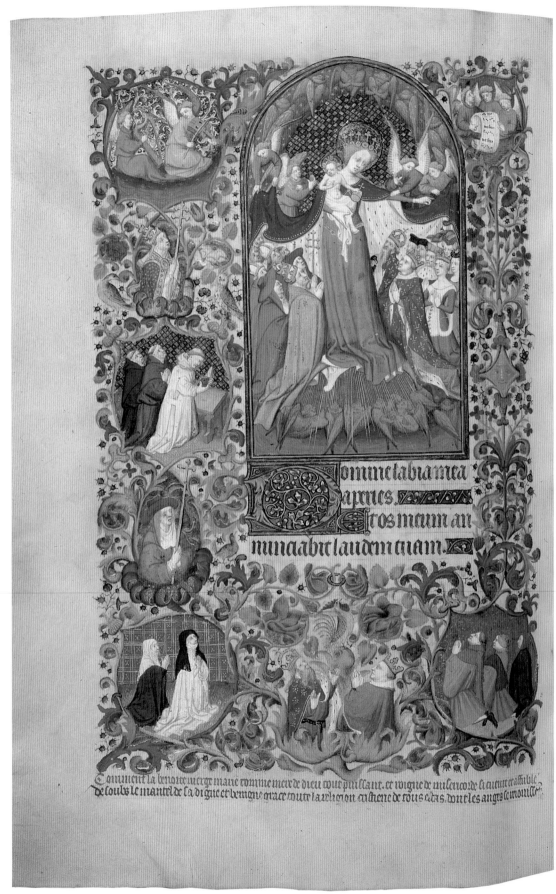

31 Hours of the Blessed Virgin (for Saturday): the Virgin of Mercy, extending her protection to all ranks of society, including an Emperor, a King of France and a Queen. In the marginal roundels other groups of the faithful, both secular and religious (f.150b).

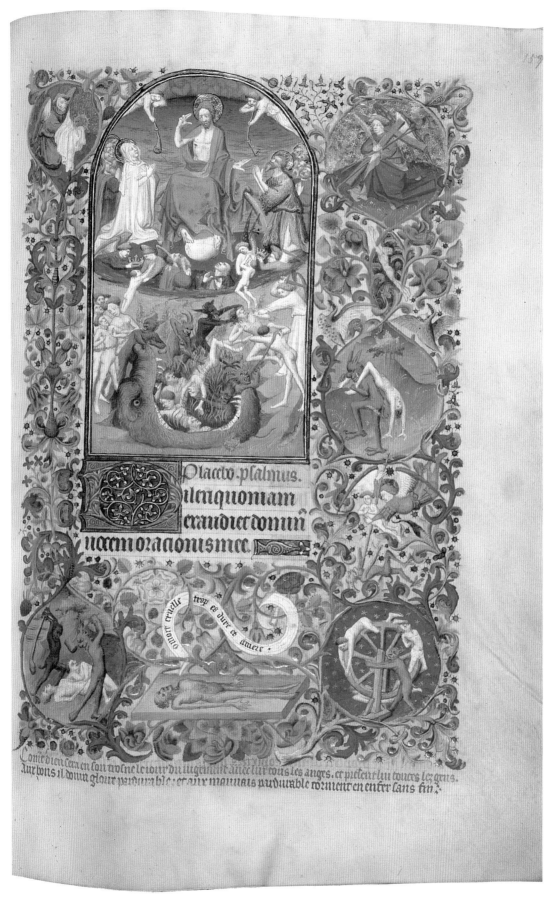

32 The Office of the Dead: the Last Judgement, with the torments of the damned (f.157).

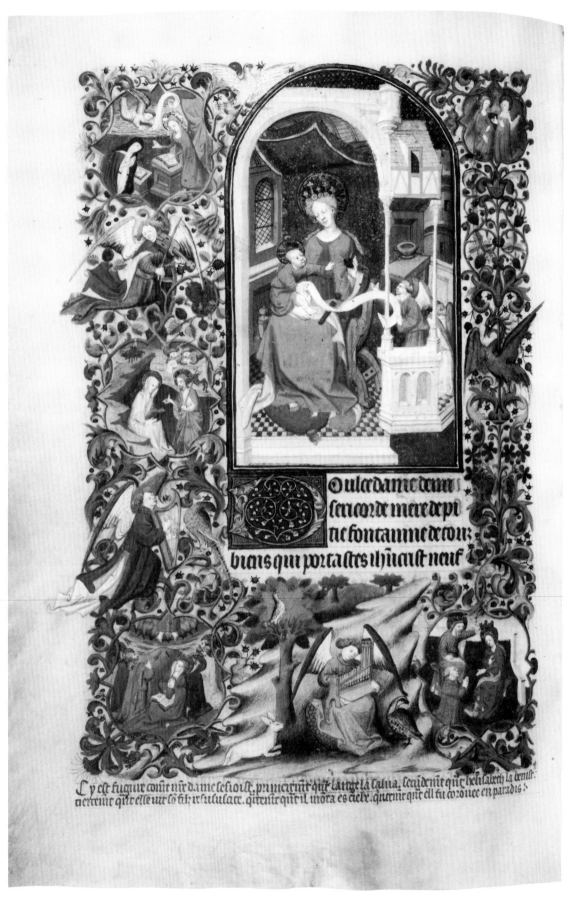

33 The Fifteen Joys of the Virgin: the Virgin and Child, with five special episodes from the Virgin's life (f.199b).

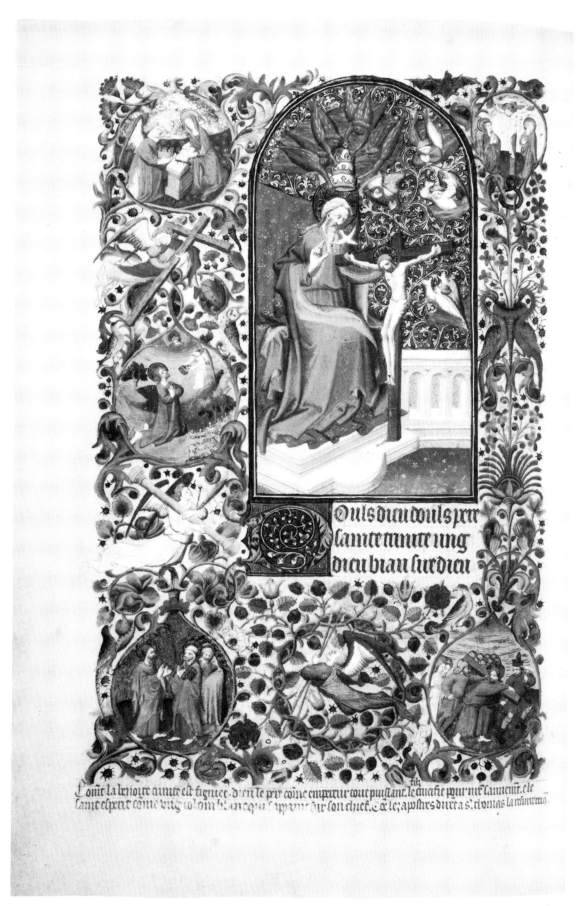

34 The Seven Requests: the Holy Trinity with Christ Crucified, with scenes from the Passion story (f. 204b).

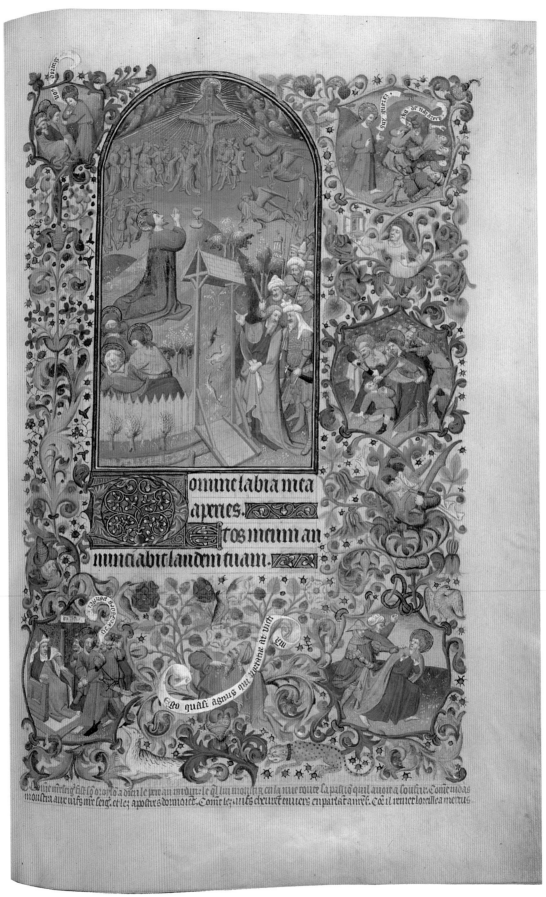

35 Hours of the Passion (Matins): Christ in the Garden of Gethsemane, anticipating the events of the Passion, with scenes of the Betrayal and Arrest (f. 208).

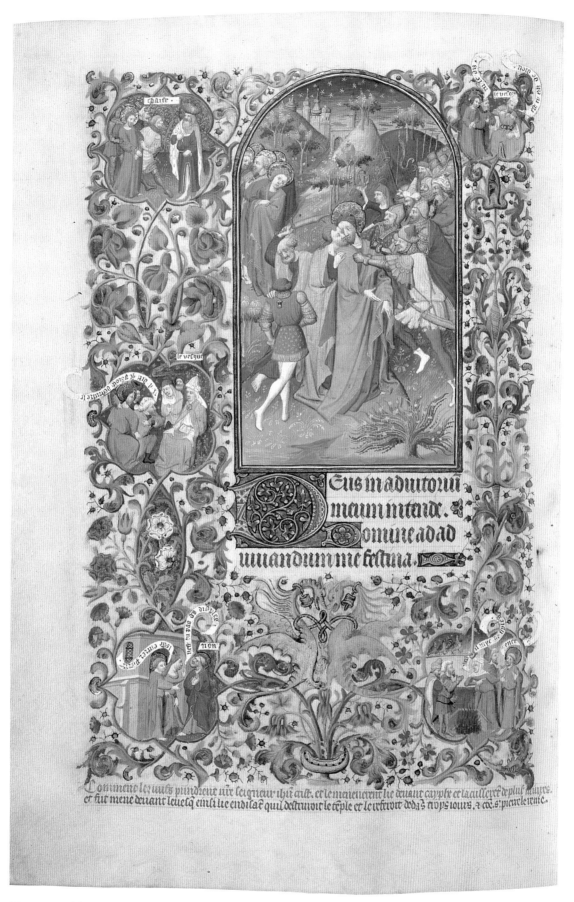

36 Hours of the Passion (Lauds): the Betrayal, with Christ before Caiaphas and the High Priest, and Peter's denial (f. 221b).

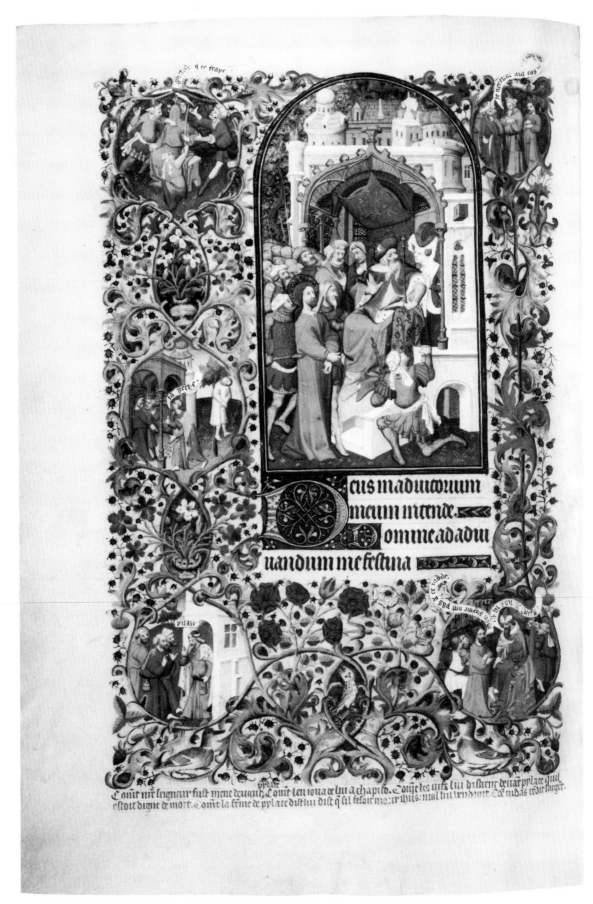

37 Hours of the Passion (Prime): Christ before Pilate, who is listening to his wife. Marginal scenes include Christ buffeted and the suicide of Judas (f. 227b).

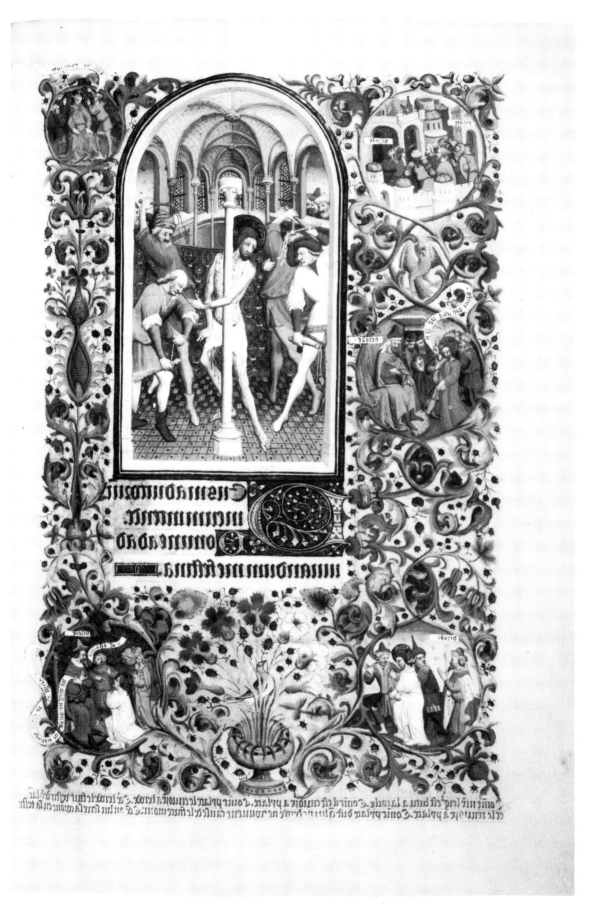

38 Hours of the Passion (Terce): Christ scourged. Marginal scenes include the crowning with thorns, Christ before Herod, and the return to Pilate (f. 230b).

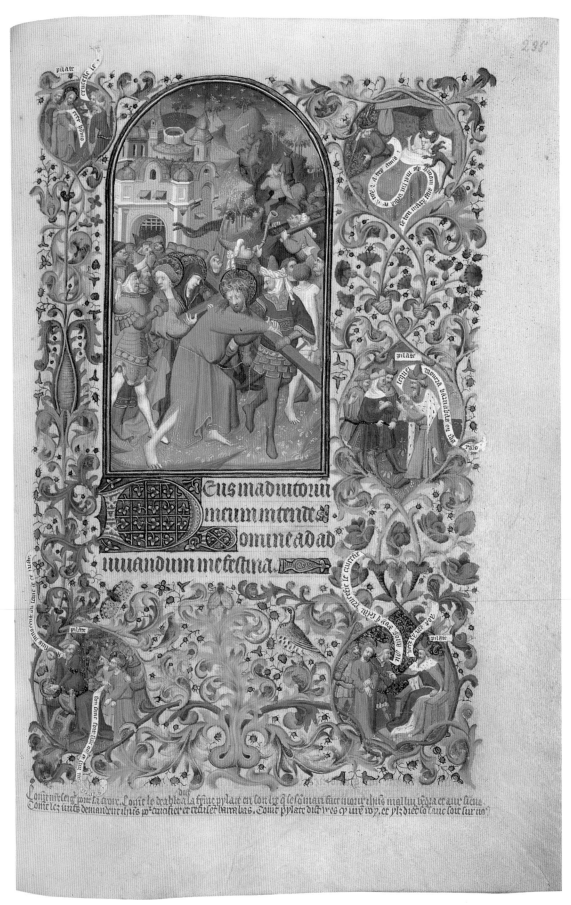

39 Hours of the Passion (Sext): Christ carrying the cross. Marginal scenes include the dream of Pilate's wife, the reprieve of Barabbas and Pilate washing his hands (f. 235).

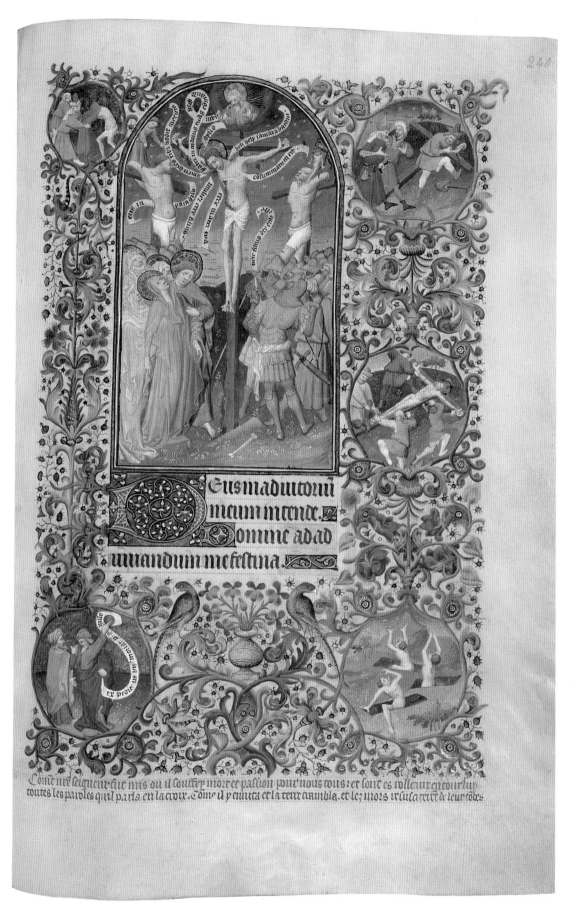

40 Hours of the Passion (None): the Seven Words from the Cross, with scenes of the Crucifixion and the dead leaving their graves (f. 240).

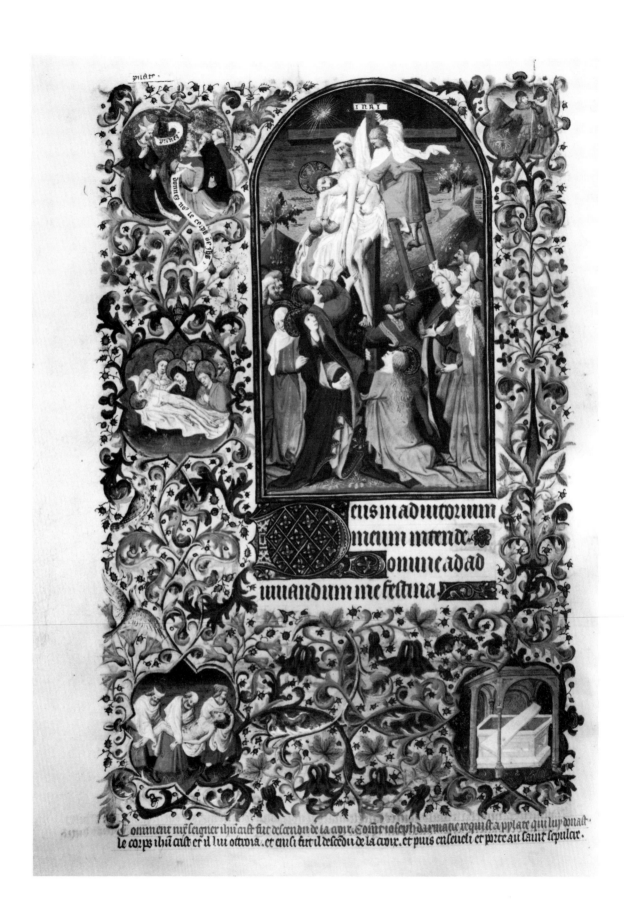

41 Hours of the Passion (Vespers): the Deposition, with scenes of the preparations for burial, including Joseph of Arimathea begging the body from Pilate (f. 245b).

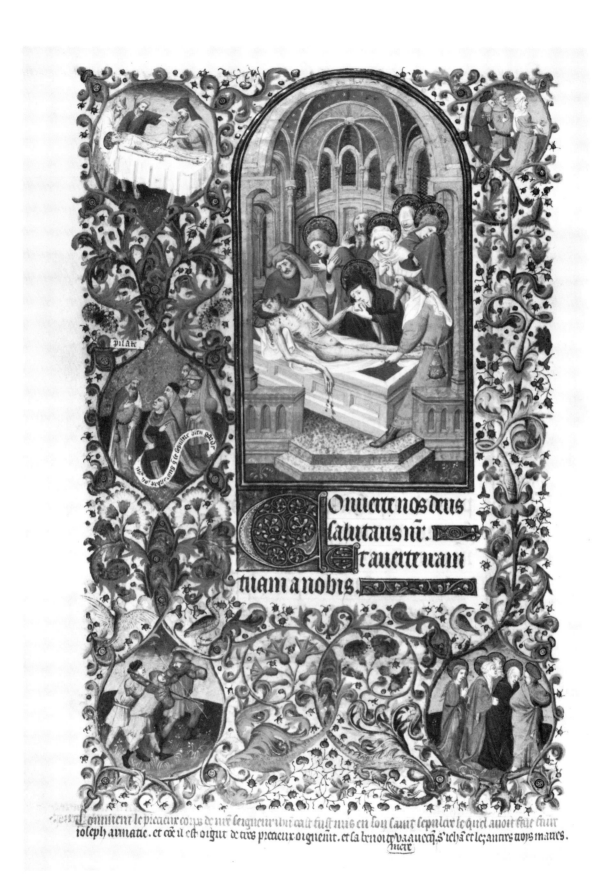

42 Hours of the Passion (Compline): the Entombment, with further scenes of preparation, including Pilate agreeing to set a guard about the tomb (f. 249b).

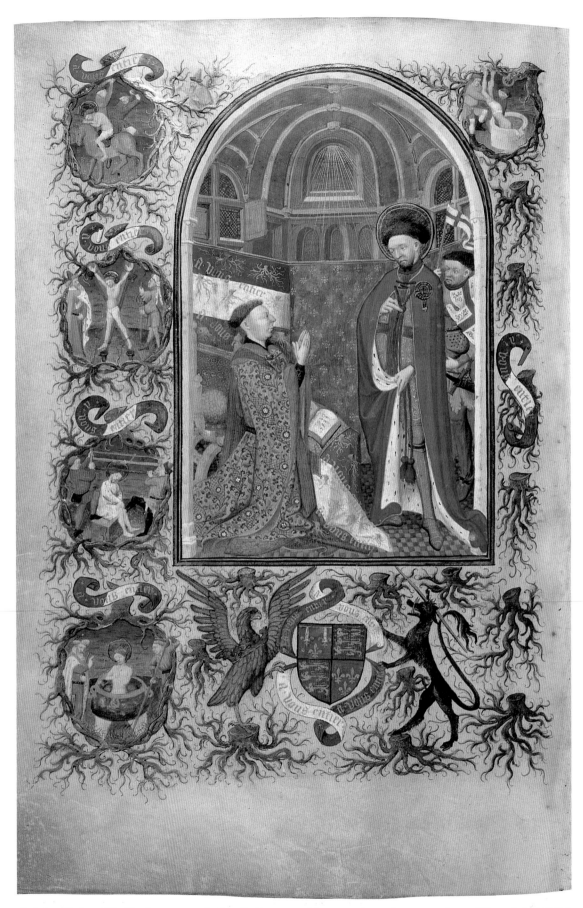

43 John, Duke of Bedford, at prayer before St George, with scenes from the martyrdom of the saint (f. 256b).

over full armour and attended by a squire carrying his helmet, shield and lance. The chronicler Waurin describes Bedford riding out in front of his troops before his great victory at Verneuil in August 1424, clad in blue velvet with a white cross on which a red cross was superimposed. This surely represented the Garter insignia.

Membership of the Order of the Garter was charged with great symbolic significance and its high ideals were regarded with the utmost respect. It was by no means unknown in the 15th century for a knight to be deprived of his membership were he to be found in breach of the code. St George's gesture towards the knot by which his mantle is fastened at his breast can probably be interpreted as a deliberate symbol of the strong ties binding the knights to each other and, in this context, to the Regent. A knot is indeed one of the badges of the Order. Diplomatic use could be made of this chivalric fellowship. The Emperor Sigismund had been admitted to the Order during his visit to England in 1416 and was thereafter popularly regarded as a sure ally, portrayed in Garter robes in one of the 'soteltes' at Henry VI's coronation banquet in 1429. An attempt had been made to reinforce the allegiance of Philip of Burgundy by the same means. He was elected to the Order in April 1422, while Henry V was still alive. He neither accepted nor declined the honour until, receiving a direct demand for an answer in the spring of 1424, he told the chapter that he felt himself unable to join the fellowship, a serious quarrel having by then arisen between him and Humphrey, Duke of Gloucester. Some six years later, at the time of his marriage to Isabella of Portugal, he founded his own Order of the Golden Fleece in the same tradition as the Order of the Garter.

This page of the manuscript is unfortunately among the few for which no 'subtitles' are provided and the subjects of the marginal roundels cannot certainly be identified. It

44 (*Left*) Marginal roundel from the Apocalypse: the locusts (f.195b detail).
45 (*Right*) Marginal roundel from the Apocalypse: the Goths, historical equivalent of the locusts (f.195b detail).

was at one time suggested that they represented the martyrdoms of the patron saints of five leading members of the Order of the Garter, including both Sigismund and Philip. It is probably more likely that they show various episodes from the extremely cruel and protracted martyrdom of St George himself.

The portrait of the Duke, and to a lesser extent that of the Duchess, shows every sign of having been drawn from the life. His face (see frontispiece), with its prominent nose and 'five o'clock shadow', is by no means flatteringly represented and reminds us that real life portraiture was one of the major artistic developments of the period. This tiny head was probably contributed by a specialist, and its technique foreshadows the work of the portrait miniature painters of the 16th century.

OWNERSHIP AND PATRONAGE

The Bedford Hours, which must have cost an immense sum of money, has traditionally been described as a gift ordered by Bedford for presentation to his bride on the occasion of their marriage. The fact that he was certainly the patron responsible for the unfinished Breviary in Paris has been used to identify him as already a major patron of the workshop that bears his name. The Breviary was not however begun until 1424, a year after the marriage and two years after Bedford's establishment as Regent resident in France. Its association with him cannot be used to imply that he must also have ordered the Hours, which is certainly the earlier of the two books.

The fact that the Hours of the Virgin are of the use of Paris while all Bedford's own liturgical books are of the English use of Sarum does certainly suggest that for practical devotional purposes the manuscript would have been of more use to the French Duchess than to her husband. However, the accumulation of political references and reflections seems more likely to have been aimed at the Duke, Regent of France and ally of Burgundy, than at his wife. All specific evidence of ownership is in fact joint. The elaborate portraits of John and Anne are on the same scale and show the partners dressed in matching fabrics and in similar settings. All the armorials display both coats of arms, and badges and mottoes appear in pairs, even in the margins of the Last Supper miniature (fig. 34), where they were probably placed on account of the prominent appearance of the Duke's personal patron, St John the Evangelist. Maybe the book was a joint offering. If so, the most likely donor is probably the bride's brother, Philip of Burgundy.

We do not know how long it would have taken to produce so enormously rich a manuscript. Certainly many different craftsmen were involved in it. Not only the thirty-eight large miniatures but also the marginal roundels and even the purely decorative work can clearly be assigned to a variety of hands. There are also signs that the manuscript was produced under a certain amount of pressure. There is no text to accompany the Old Testament pictures, leaving awkward gaps at the beginning of the book, and the frames around the labours of the months and the zodiac signs in the calendar are incomplete. In several places clumsy textual corrections were made after the marginal decoration had been supplied, so that portions of it had to be erased, which implies that the illuminators were following so hard upon the heels of the scribe that checking and

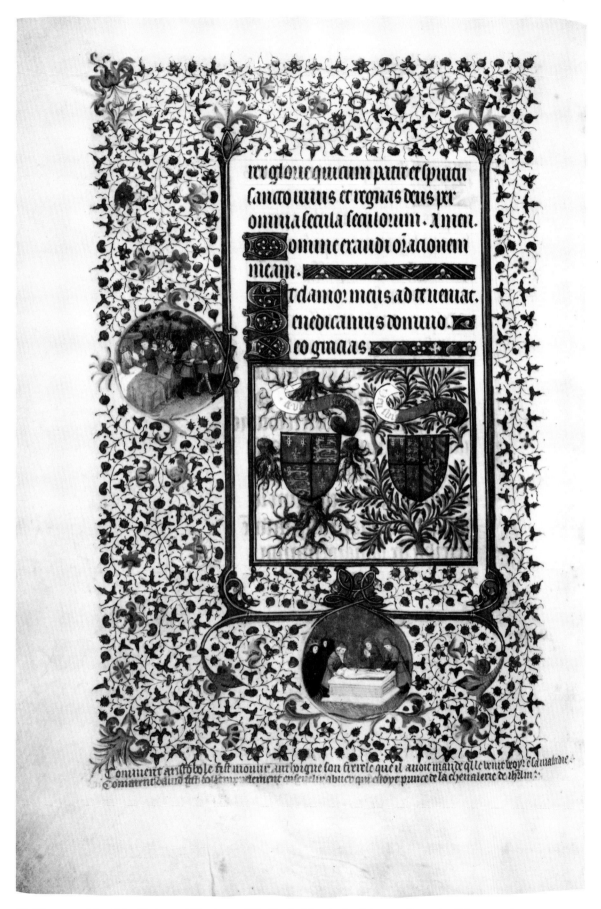

46 The armorials of the Duke and Duchess of Bedford. Marginal miniatures from the 'Montereau' sequence, showing (left) Aristobolus murdering his brother Anthony on his sickbed and (below) David raising Abner's body from the tomb (f. 255b).

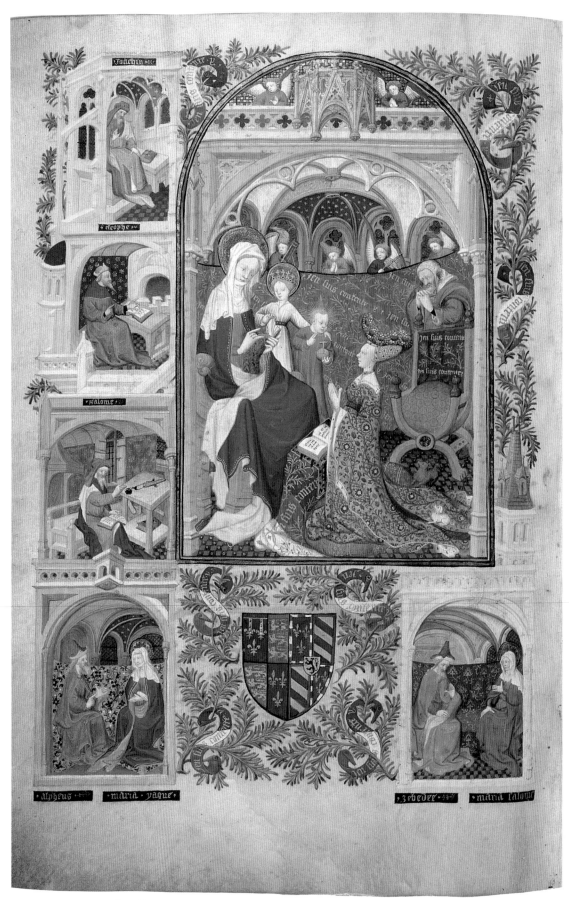

47 Anne, Duchess of Bedford at prayer before St Anne, with figures of St Anne's family (f. 257b).

adjustment could not keep pace with them. Other corrections were made within the text areas, and one at least (f.134) was carried out with so little care that a vellum patch had to be applied to conceal the damage.

These small signs may hint at a degree of haste to meet a deadline. If the marginal scheme does indeed include references to the assassination of John the Fearless, and specifically to the removal of his body to Dijon, it cannot have been begun before the midsummer of 1420. A marriage between one of Henry V's brothers and a sister of Burgundy was by then already in the air. The marriage specifically between Bedford and Anne was projected in October 1422 and solemnised in May 1423, and it is certainly to this alliance that the book belongs. It is hard to imagine so complex a scheme being devised and completed within a six-month period, but a date about 1423 seems certain.

A CHRISTMAS GIFT

The manuscript was certainly complete and in the hands of the Bedfords before 1430. On Christmas Eve 1430 the Duchess, with her husband's approval, offered the Hours as a gift to their nephew, nine-year-old Henry VI, who was staying with them at Rouen before his French coronation. At the Duke's request, the transaction was recorded in detail in a long inscription added on the blank page which precedes his own portrait (f.256). The relationships of the Regent to his young nephew and of his wife to the Duke of Burgundy, the beauty and richness of the book, and the propinquity of the portrait

48 Marginal roundel from the calendar: Februa, mother of Mars, who gives her name to February (f. 2 detail).

49 Marginal roundel from the calendar: the Pleiades, led by Maya, who gives her name to May (f. 5 detail).

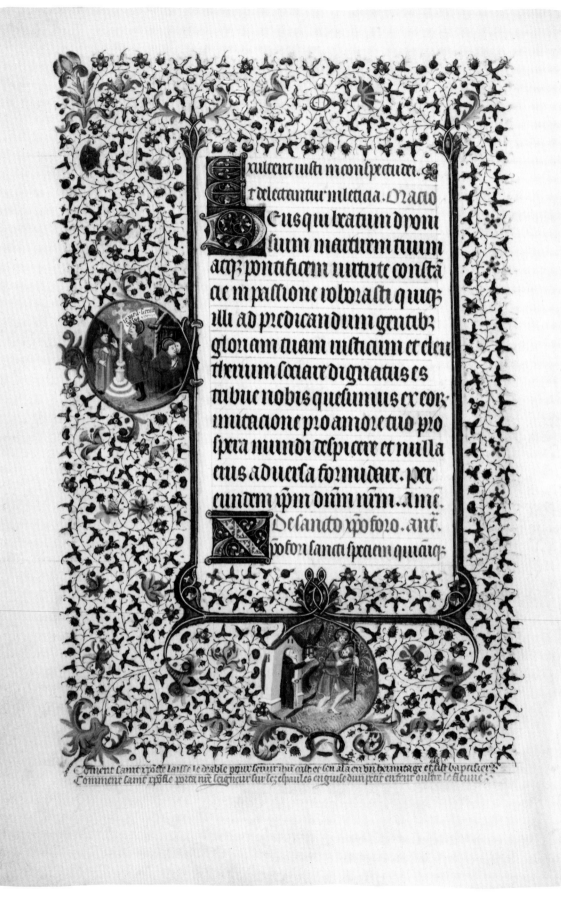

50 Memorials of the saints: marginal scenes from the story of St Christopher (f. 269b).

of the Duke are all mentioned in the inscription, which was calligraphically written and initialled by Dr John Somerset, the young king's tutor and personal physician.

Henry was only seven years old when political events made his French coronation an urgent necessity. During 1429 the Dauphin's failing cause had received an unlooked-for injection of success through the victories of Joan of Arc, who personally led him to his coronation as Charles VII at Rheims in July of that year. Henry's guardians arranged for his English coronation to take place at Westminster in November, a month before his eighth birthday, and on St George's Day 1430 he was taken across the Channel on the first stage of the journey to his second crown. The unstable situation in France obliged him to spend some months at Calais, but in May Joan was captured by the Duke of Burgundy's troops and Henry was eventually taken to the English headquarters at Rouen, to which Joan too was transferred in December. It is recorded that the Duchess of Bedford was kind to the prisoner, providing her with warm clothing, offering the services of her own physician when the Maid was ill, and doing her best to shield her from rough handling by the guards.

Once Henry and his Council had arrived in France, Bedford's responsibilities as Regent were suspended in their favour. The gift of the manuscript and the accompanying inscription were probably designed to remind Henry of the debt which he owed his uncle for the safekeeping of his French kingdom. At the end of January 1431 the Bedfords left Rouen for Paris where they remained for the rest of the year, including the whole period of the trial and execution of Joan, which took place in Henry's name. The military situation improved in England's favour, and in December 1431 Henry at last made his state entry into Paris and was crowned in the cathedral of Notre Dame nine days before Christmas. One of the tableaux which welcomed him showed Bedford among those offering him the English crown and Burgundy in a similar role with the crown of France. Philip of Burgundy was however absent from the coronation, as he had been from the crowning of Charles VII in 1429.

On Henry's return to England in February 1432, Bedford resumed the title of Regent, but his old alliance with Burgundy was never fully resumed. In November he suffered a crushing blow when the Duchess, still aged only twenty-nine, died in Paris. As a diplomatic bond between two important powers, the Bedford marriage had been an outstanding success, with Anne on several occasions healing potential breaches between her husband and the brother with whom she had always been a favourite. On a personal level, the union of John of Lancaster and Anne of Burgundy, embarked upon for reasons of political expediency, had been in the end a great romance. The Regent and his wife were celebrated for their devotion to each other and the Bedford Hours, one of the most beautiful books of its time, can also be regarded as a memorial to one of the outstanding love affairs of the early 15th century.

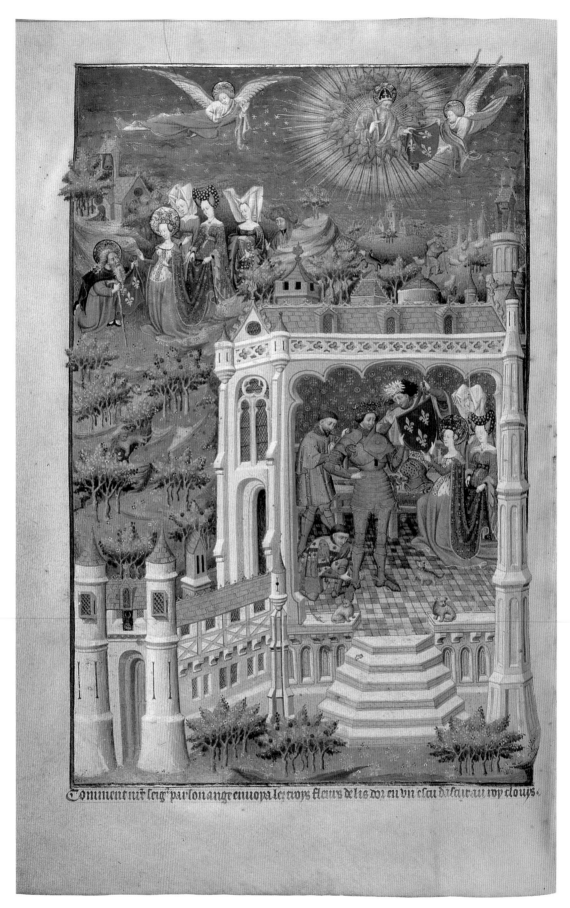

51 The Legend of the fleurs de lys (f. 288b).

AN OUTLINE OF THE STRUCTURE AND CONTENTS OF THE BEDFORD HOURS

Section 1: folios 1–12. One gathering of 12 leaves. The calendar, with appropriate illustrations.

Insertion A: folios 13–18. 2+1+1+2 leaves. Large miniatures at folios 14 (Adam and Eve), 15ᵛ (Building the Ark), 16ᵛ (the Exit from the Ark), and 17ᵛ (the Tower of Babel). Bedford armorial tree, full-page, at folio 15. Last leaf blank.

Section 2: folios 19–31. One gathering of 8 plus 4+1 leaves. Extracts from the Four Gospels, followed by 'Obsecro te' and 'O intemerata'. Large miniatures at folios 19 (St. John), 20ᵛ (St. Luke), 22 (St. Matthew), and 24 (St. Mark). Historiated initials at folios 25 and 28ᵛ, beginning the two prayers. Marginal roundels from the Life of Christ (from the Annunciation to Zacharias to the cleansing of the Temple). Bedford arms at folios 23ᵛ and 31. Verso of last leaf blank.

Section 3: folios 32–95. Eight gatherings of 8 leaves. The Hours of the Virgin. Large miniatures at folios 32 (Annunciation), 54ᵛ (Visitation), 65 (Nativity), 70ᵛ (Annunciation to the Shepherds), 75 (Adoration of the Magi), 79 (Presentation), 83 (Flight into Egypt), and 89ᵛ (Death of the Virgin). Historiated initial at folio 32, introducing the opening lines of the Hours, which are written in gold. Marginal roundels from the Life of Christ (from Christ preaching from the water to the Ascension). Bedford arms at folio 94ᵛ. Last leaf blank.

Section 4: folios 96–207. Fourteen gatherings of 8 leaves. Subsidiary devotions–the Penitential Psalms etc., Hours (of the Trinity, of the Dead, of All Saints, of the Holy Spirit, of the Holy Sacrament, of the Cross, and of the Blessed Virgin) assigned to each of the seven days of the week, the Office of the Dead, the Fifteen Joys, and the Seven Requests. Large miniatures at folios 96 (David and Bathsheba), 113ᵛ (Holy Trinity as Creator), 120 (Funeral), 126 (All Saints), 132 (Pentecost), 138 (Last Supper), 144 (Crucifixion), 150ᵛ (Virgin of Mercy), 157 (Last Judgement), 199ᵛ (Virgin and Child), and 204ᵛ (Holy Trinity as Redeemer). Marginal roundels from Acts and Epistles and (from fol. 170ᵛ) from the Apocalypse, with a hiatus showing the Apostles' Creed etc. at folios 160–167ᵛ. Bedford arms at folio 207ᵛ. Bedford mottoes in the margins of folios 138.

Section 5: folios 208–55. Six gatherings of 8 leaves. The Hours of the Passion. Large miniatures at folios 208 (Agony in the Garden), 221ᵛ (Betrayal), 227ᵛ (Christ before Pilate), 230ᵛ (Scourging), 235 (Carrying the Cross), 240 (Seven Words from the Cross), 245ᵛ (Deposition), and 249ᵛ (Entombment). Marginal roundels from the Apocalypse followed by (fols. 253ᵛ–255ᵛ) the 'Montereau' subjects. Bedford arms at folio 255ᵛ.

Insertion B: folios 256–9. One gathering of 4 leaves. Ducal personal prayers. Large miniatures at folios 256ᵛ (Bedford before St. George) and 257ᵛ (the Duchess before St. Anne). Marginal roundels related to miniatures. Bedford arms in borders to main miniatures. Recto of first leaf blank, with added inscription by John Somerset, 1430. Last leaf blank.

Section 6: folios 260–87. Three gatherings of 8 and one of 4 leaves. Memorials of saints and special masses. No large miniatures. Marginal roundels related to the adjacent text. Bedford arms at folio 287ᵛ.

Insertion C: folios 288–9. One gathering of 1+1 leaves. The story of Clovis and the fleurs-de-lys. Large miniature at folio 288ᵛ (the presentation of the fleurs-de-lys to Clovis by Clothilda). Marginal roundels from the story of Clovis. No arms. Recto of folio 288 blank.

FURTHER READING

The only attempt to produce a detailed description of the Bedford Hours, now itself two centuries old, is R. Gough, *An Account of the Rich Illuminated Missal Executed for John Duke of Bedford*, London 1794. More recent material will be found in E. P. Spencer, 'The Master of the Duke of Bedford: The Bedford Hours', *Burlington Magazine*, cvii, pp. 495–502, London 1965 and J. Backhouse, 'A reappraisal of the Bedford Hours', *British Library Journal*, vii, pp. 47–69, London 1981. Some of the political allusions are discussed in B. J. H. Rowe, 'Notes on the Clovis miniature and the Bedford Portrait in the Bedford Book of Hours', *Journal of the British Archaeological Association*, third series, xxv, pp. 56–65, London 1962. The subsequent history of the manuscript is traced in the first chapter of A. N. L. Munby, *Connoisseurs and Medieval Miniatures*, Oxford 1972.

Other manuscripts owned by Bedford are detailed by J. Stratford, 'The manuscripts of John, Duke of Bedford: Library and Chapel', *England in the Fifteenth Century (Proceedings of the 1986 Harlaxton Symposium)*, ed. D. Williams, pp. 329–50, Woodbridge 1987, and more specifically discussed in D. H. Turner, 'The Bedford Hours and Psalter', *Apollo*, lxxvi, pp. 265–70, London 1962, E. P. Spencer, 'The Master of the Duke of Bedford: The Salisbury Breviary', *Burlington Magazine*, cviii, pp. 607–12, London 1966; and C. Reynolds and J. Stratford, 'Le manuscrit dit "Le Pontifical de Poitiers"', *La Révue de l'Art*, lxxxiv, pp. 61–80, Paris 1988.

For Books of Hours in general see J. Backhouse, *Books of Hours*, London 1985 (drawing upon the collections of The British Library) and R. Wieck, *The Book of Hours in Art and Life*, London 1988 (concentrating on manuscripts from American collections).

The following biographies are particularly useful: E. Carleton Williams, *My Lord of Bedford 1389–1435*, London 1963; B. P. Wolffe, *Henry VI*, London 1981; M. G. A. Vale, *Charles VII*, London 1974; R. Vaughan, *John the Fearless*, London 1966 and *Philip the Good*, London 1970. Bedford's childhood and youth are most readably chronicled in Georgette Heyer's posthumously-published novel, *My Lord John*, London 1975.

52 Special masses: marginal roundel of the Holy Spirit renewing the earth (f. 278b detail).